DRAGGING →

PAINTING THE MARINE SCENE IN WATERCOLOR

WAITING FOR THE FOG TO LIFT →

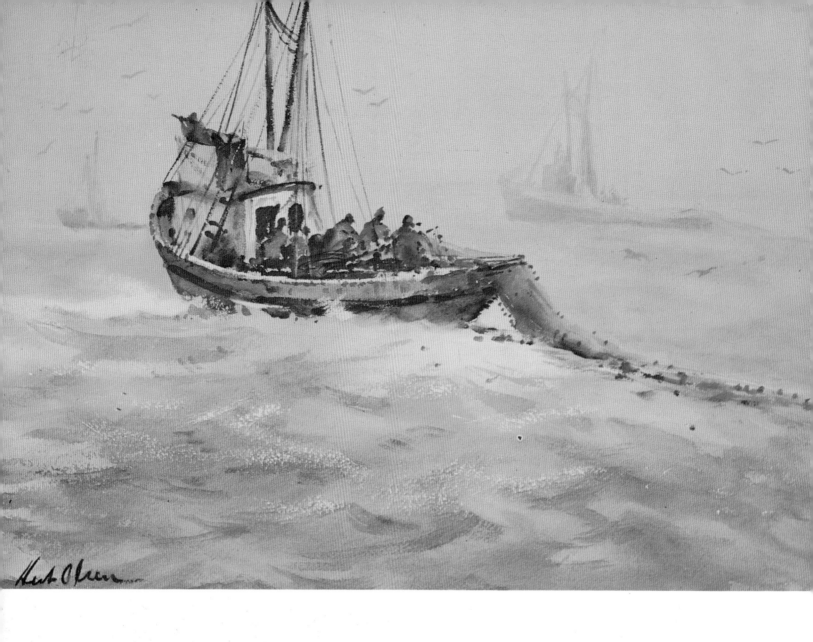

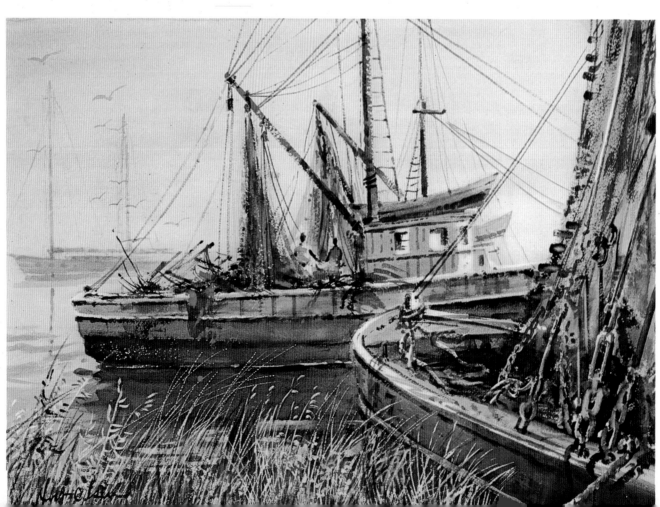

PAINTING THE MARINE SCENE IN WATERCOLOR

BY *Herb Olsen*, A.N.A.

Galahad Books New York City

To my friends:

Herbert L. Pratt
E. C. McCormick, Jr.

Other Books by Herb Olsen, A. N. A.
Guide to Watercolor Landscape
Painting Children in Watercolor
Painting the Figure in Watercolor
Watercolor Made Easy

Library of Congress Catalog Card Number: 75-37434
ISBN: 0-88365-335-4

Published by arrangement with Van Nostrand Reinhold Company
450 West 33rd Street, New York, N.Y. 10001

Designed by Emilio Squeglio

CONTENTS

COLOR PLATES

FOREWORD

Nearly seven-eighths of the earth's surface is covered with water. Besides being essential to all forms of life, water furnishes the world with a great deal of beauty and the urge to paint this beauty is shared by many artists.

In its broadest sense, painting the Marine Scene would include all categories of waters, whether they are oceans, lakes, or rivers, and everything pertaining to the life and activities on them or along their shores. But more specifically and for the purposes of this book, a marine painting is primarily a painting of the sea and the seashore. It is a subject that is difficult to limit to a few isolated situations and problems, for they are legion.

To try to record the fluid movement of water on a flat piece of paper is not the easiest thing to do, but I have tried to simplify the task. My approach to painting water begins with an analysis of its construction, because, intangible as it is, water does have form and structure, though ever-changing. To capture this in frozen detail demands a great deal of observation and study. The patterns formed by waves, for example, are blocked in in large shapes. These shapes are loosely indicated in the painting and details are added in many steps. Several examples of this procedure are shown in the book.

At the risk of being called partial, which of course I am, I would like to say that in my opinion watercolor is a "natural" for painting the marine scene in all of its manifestations—perhaps because its medium is water. There is a freedom and fluidity possible that is characteristic only of watercolor. Accidental effects are additional attributes of the medium.

The constantly changing moods of the sea are almost hypnotic to me. Rarely does a day pass that I do not go to the shore to watch and study the waves, to listen to the whine of the gulls, and to look at the boats coming and going—pleasure boats as well as fishing craft. The results of these many years of observation are recorded here to the best of my ability in the hopes that they will be of help to you.

This book is to be used as a Guide, and consequently I have tried to include as many phases of the sea as possible—its followers, its fishermen and their equipment, its craft, birds, shells, driftwood, and other things typical of the scene. No attempt has been made to organize the material in any formal sequence, so use the book as it is meant to be used, as a reference book that will assist you in difficult situations. Consult the Table of Contents for help in locating subjects and solutions. I sincerely hope that within these pages you will find the answers to your problems of Painting the Marine Scene.

Sincerely,

Herb Olsen, A.N.A.

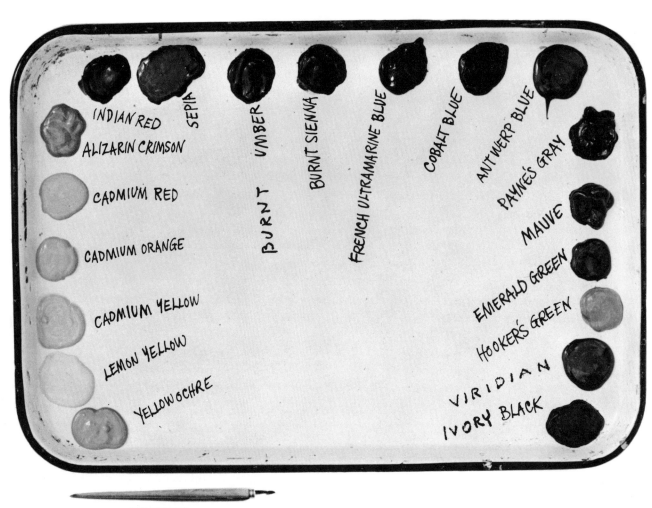

INDIAN RED
SEPIA
ALIZARIN CRIMSON
CADMIUM RED
CADMIUM ORANGE
CADMIUM YELLOW
LEMON YELLOW
YELLOW OCHRE
BURNT UMBER
BURNT SIENNA
FRENCH ULTRAMARINE BLUE
COBALT BLUE
ANTWERP BLUE
PAYNE'S GRAY
MAUVE
EMERALD GREEN
HOOKER'S GREEN
VIRIDIAN
IVORY BLACK

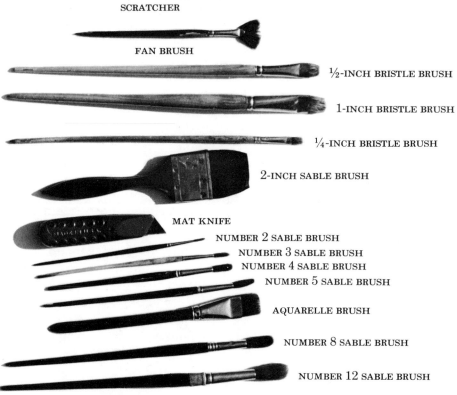

SCRATCHER

FAN BRUSH

½-INCH BRISTLE BRUSH

1-INCH BRISTLE BRUSH

¼-INCH BRISTLE BRUSH

2-INCH SABLE BRUSH

MAT KNIFE

NUMBER 2 SABLE BRUSH

NUMBER 3 SABLE BRUSH

NUMBER 4 SABLE BRUSH

NUMBER 5 SABLE BRUSH

AQUARELLE BRUSH

NUMBER 8 SABLE BRUSH

NUMBER 12 SABLE BRUSH

SPONGE

MASKOID

RUBBER CEMENT PICK-UP

3-INCH SABLE BRUSH

1. MATERIALS

The materials I used in doing the paintings shown in this book are relatively few. The tools used and how to use them are covered in each step-by-step lesson. My four previous books on watercolor painting have extensive chapters on materials that are used in all types of subject matter; therefore I feel it is not necessary to repeat this in detail here. However, on the opposite page you will see the full Olsen palette of colors and a complete selection of brushes and accessories.

The four main categories of material include *Paper, Color, Brushes,* and *Accessories.* The paper I generally use, and used for the paintings shown throughout this book, is D'Arches 300 lb. rough. This is a personal preference. Any good hand-made rag paper can be substituted if so desired. The choice of brand of color is also largely a personal preference. I use Rembrandt and Grumbacher. A full set of brushes, while desirable, is not entirely necessary, but in my opinion the two indispensable and most useful brushes are the number 8 brush and the Aquarelle brush. The accessories shown are well known to most painters, with the possible exception of *Maskoid, Rubber cement pickup,* and the *Scratcher.*

Throughout the book you will see that I make frequent use of Maskoid. This is a liquid masking solution that is easy to apply and dries quickly to form a protective coating on areas that are meant to be kept white. Because it is possible to paint right across the areas protected by the Maskoid the necessity of painting around them is eliminated. Maskoid should be applied with as much care as paint. Never use a good brush as Maskoid is ruinous to brushes. When dry it is removed with a rubber cement pickup, leaving the applied surface white. When Maskoid is used to cover an area that involves a good deal of drawing, this area should first be painted with a wash of color. The wash will serve as a protective covering for the pencil drawing which would otherwise be rubbed out during the removal of the Maskoid with the pickup.

The scratcher is used instead of a razor blade for removing color to bring back the whites. It is an inexpensive tool that looks like an old-fashioned pen but with a spoon-shaped point. The scratcher is most successful in small areas, because of the tedium involved, but with great patience even large areas of color can be removed. When the scratched area is repainted, no sign of the scratching can be seen. Do not apply too much pressure in its use.

THE OLSEN PALETTE, OPPOSITE

For my palette I use a large white enameled butcher's tray, 19 inches by 13 inches. This holds a wide assortment of pigments in generous amounts, leaving ample room for mixing colors. As you see, I arrange my colors from warm to cool. This grouping works very well for me, but other arrangements may suit you better. However, no matter how you arrange your colors you should have a definite plan so you can reach for a color without fumbling. Be sure to keep plenty of pigment on your palette so you won't run out of color in the middle of a wash.

It is important to know that in the case of certain equivalent blue and green colors names vary according to the manufacturer. In the paintings in this book I used Rembrandt and Grumbacher but there are excellent equivalents manufactured by Winsor Newton. This should be kept in mind as you follow my painting procedures. Below is a list of color equivalents.

BLUE: Rembrandt *Permanent Blue,*
 New Blue,Ultramarine Extra Light
 Grumbacher *French Ultramarine*
 Winsor Newton *French Ultramarine*
BLUE: Rembrandt *Antwerp Blue*
 Grumbacher *Thalo Blue*
 Winsor Newton *Winsor Blue*
GREEN: Rembrandt *Rembrandt Green*
 Grumbacher *Viridian*
 Winsor Newton *Viridian*

2. THE WHARF

This wharf scene has in it much of the familiar equipment used by those whose livelihood depends on the sea. It is dominated by the Gull— a king of the sea birds, who also lives on "the catch." You will notice that in the first drawing, opposite, I included the figure of a fisherman, but I eliminated this as the picture progressed, for two reasons. First, I felt that it created a second center of interest, and second, it detracted from the Gull who is coming back to the now deserted pier for a little clean-up job, better done without any human presence. The finished painting is reproduced in color on page 19.

On page 18 will be found three other examples of dock paintings—one in which the fishing sheds are a part of a sea-scape, another showing a child day-dreaming as she watches the water from a dock, and a close-up of a lobster shed incorporating many of the accessories pertinent to the trade. The last painting mentioned, entitled BAIT, BOATS AND BUOYS, won the Digby Chandler Award in the Allied Artists Exhibit in 1962.

MATERIALS

PAPER:	D'Arches, 300 lb., full sheet (22 by 30 inches)
PENCIL:	HB
BRUSHES:	Aquarelle and Number 8
SCRATCHER	
COLORS:	Yellow Ochre
	Permanent Blue
	Burnt Sienna
	Ivory Black
	Hooker's Green
	Sepia
	Cobalt Blue
	Burnt Umber
	Thalo Blue
	Veridian
	Orange
	Ultramarine Blue
	Middle Yellow
	Antwerp Blue

THE WHARF
STEP-BY-STEP PAINTING PROCEDURE

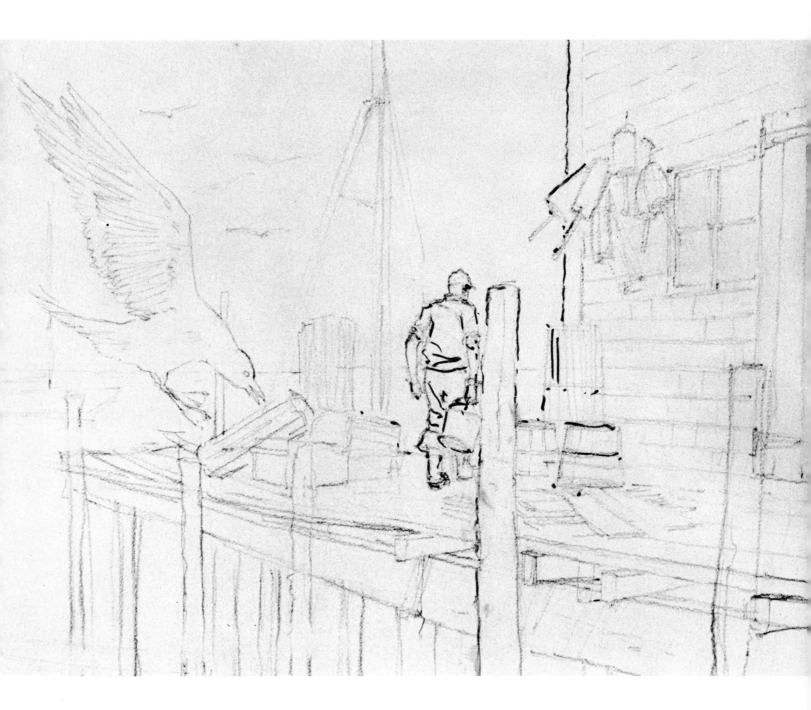

Step 1. After a careful drawing has been completed, apply Maskoid to the gull. When dry, sponge the entire surface of the paper with clean water. See the Gulls section pages 115-119 for help in drawing and painting the gull.

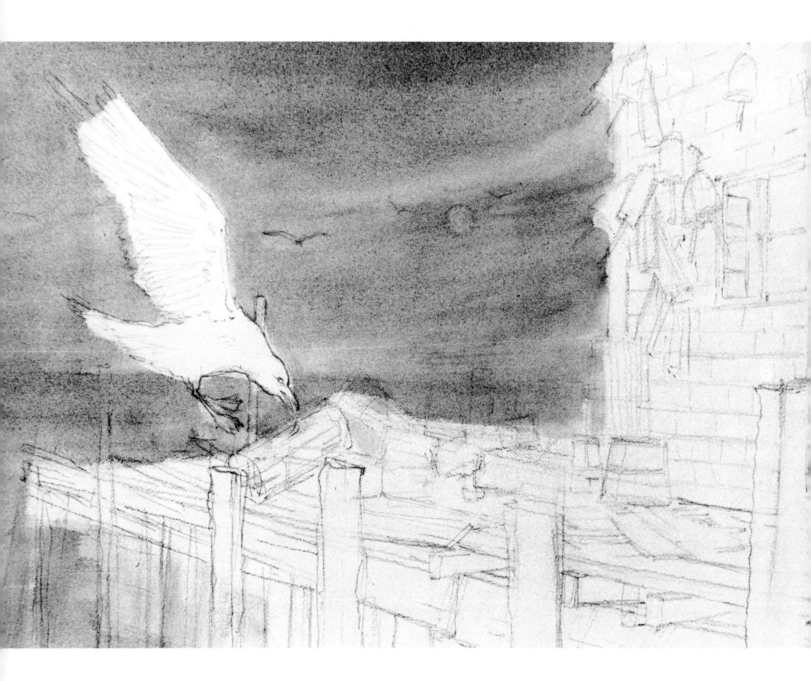

Step 2. While the paper is damp, paint the
sky and water area in horizontal strokes with a
sponge, using Yellow Ochre and Permanent
Blue mixed on the palette. When dry, darken
the water from the horizon line to the beach
line with the Number 8 brush and the same col-
ors. When dry, remove the Maskoid from the
gull.

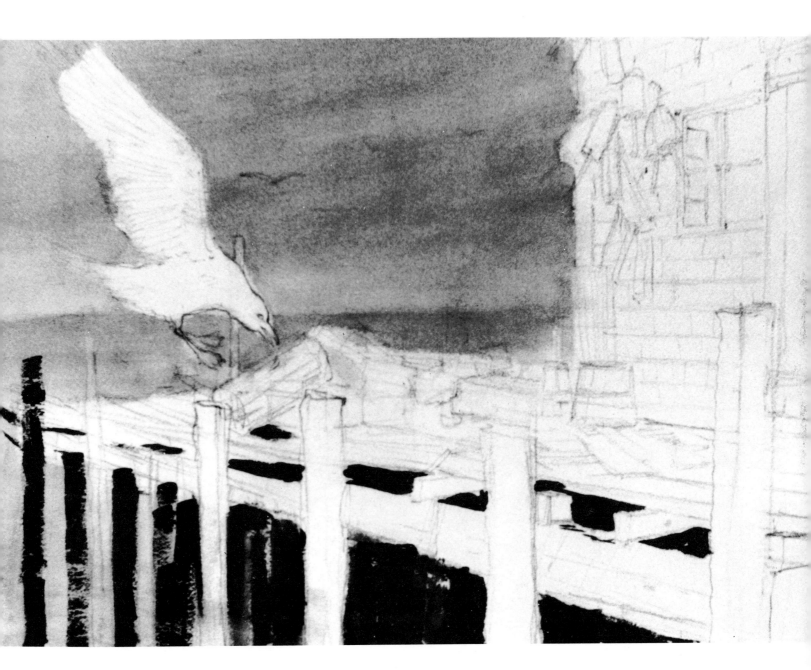

Step 3. With the Aquarelle brush paint darks
under the decks as indicated, using Burnt Si-
enna, Hooker's Green, Sepia, Cobalt Blue, Burnt
Umber, Thalo Blue, Veridian, mixed freely on
paper, at random.

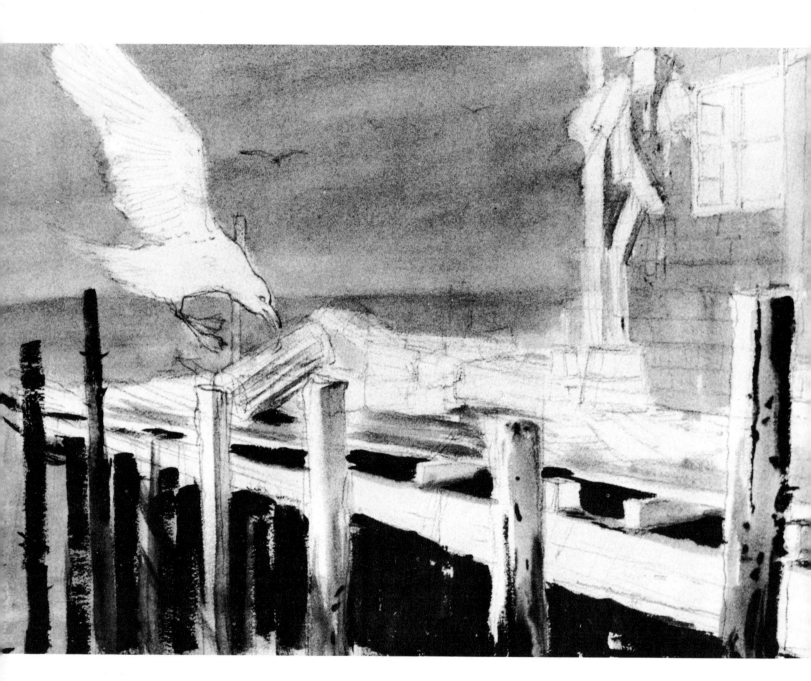

Step 4. Paint shed. Use the Aquarelle brush
and apply a very light wash of Hooker's Green,
Burnt Sienna, and Ivory Black mixed on the
paper. Then paint the posts with the Number
8 brush using Cobalt Blue running into Orange.
While wet, paint darks using Sepia. Let dry.

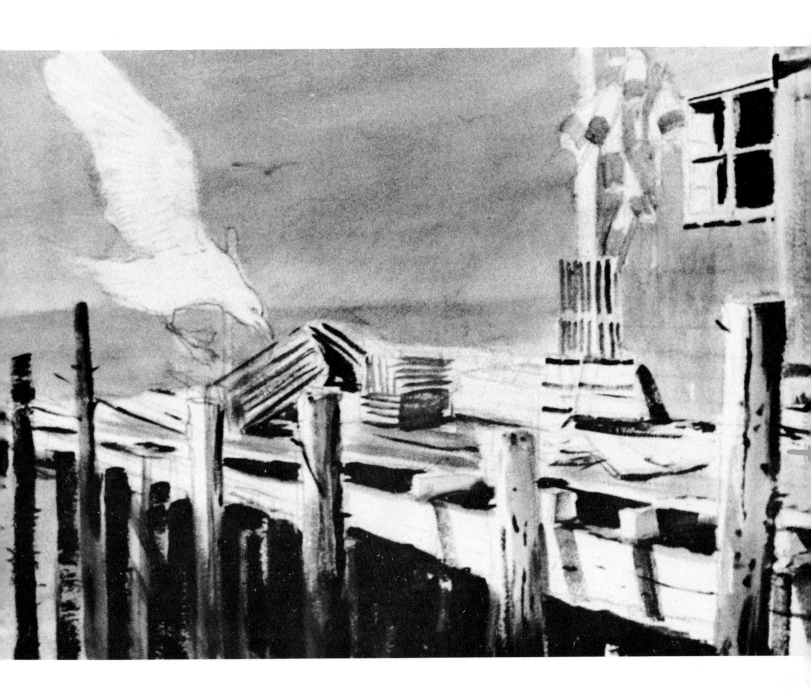

Step 5. Continue to build up the painting with
the same colors as in Step 4, but intensified.

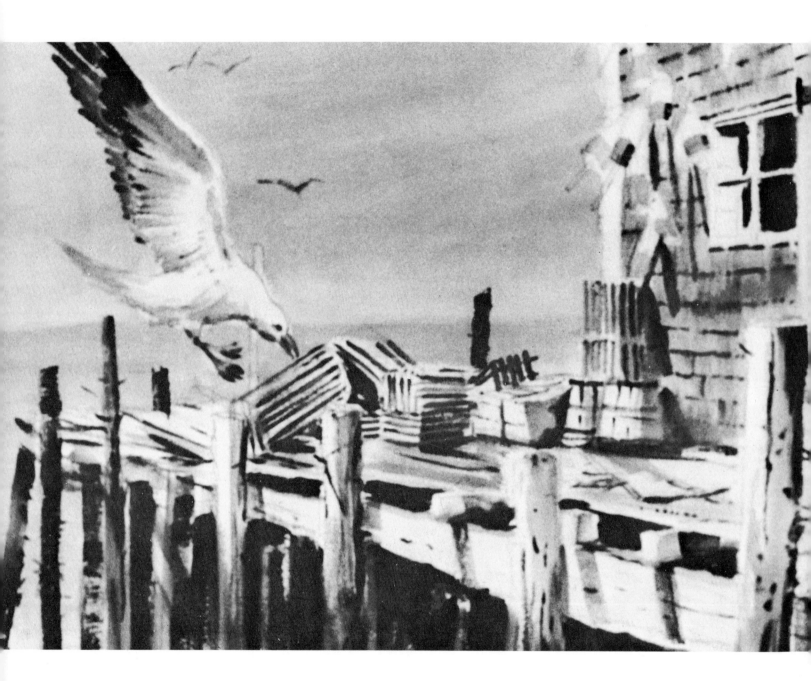

Step 6. Paint the large gull with the Number 8 brush. First paint dark wing tips using Sepia, Burnt Sienna, Thalo Blue, and Orange mixed on the paper. Then paint shadow areas of the body and wings with a light wash of Orange and Ultramarine Blue. The gull's bill is Middle Yellow. Add dark accents to the crates, using Sepia and Burnt Sienna.

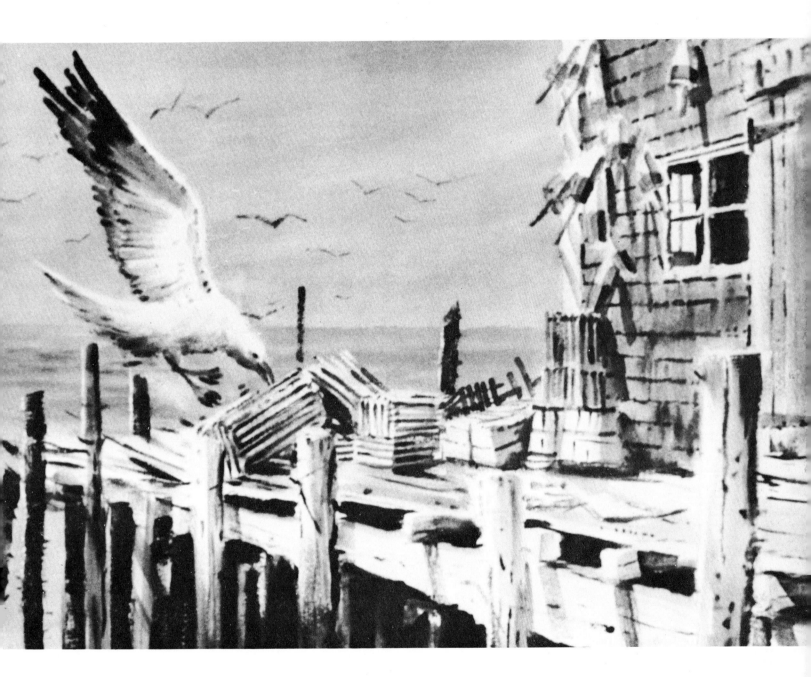

Step 7. Paint shadows of the markers on the shed with Permanent Blue and Sepia mixed on palette—leaning toward the Blue. With the Aquarelle brush, paint over the darker portions of lobster crates using Antwerp Blue, Lemon Yellow, Permanent Blue, and Sepia mixed on the paper. Dingie is Lemon Yellow.

Step 8. Finish the painting. Add tall posts with connecting ropes, using Burnt Sienna and Sepia mixed on paper and applied with the Number 8 brush—dry. Paint the small gulls. Then finish the large gull. Notice that the tail feathers are painted *over* the post to bring the bird closer into the foreground. With a scratcher (see Materials, page 9) scratch out whites for the foam of the waves.

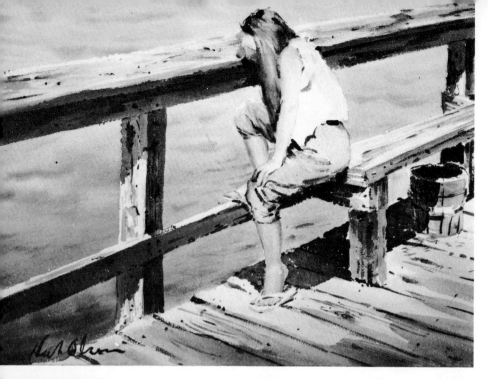

A Little Girl's World

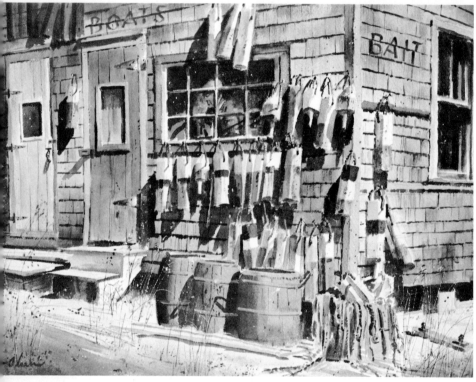

Bait, Boats, and Buoys

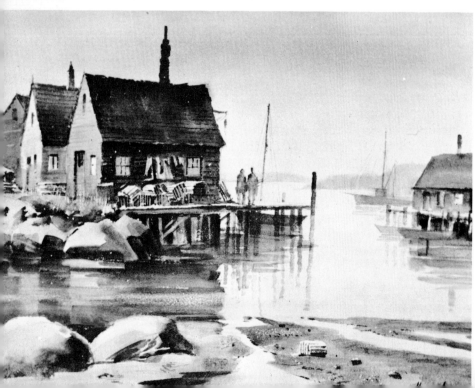

Seascape with Fishing Sheds

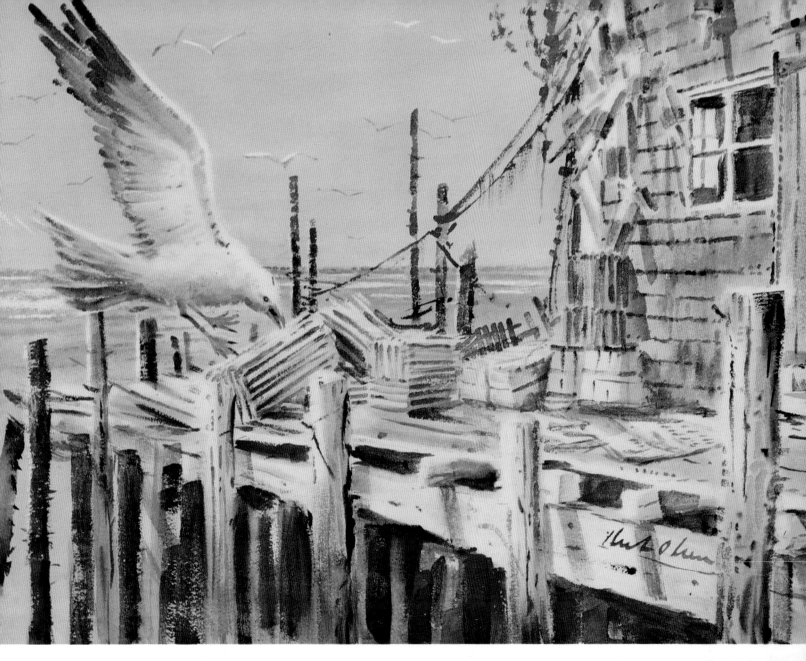
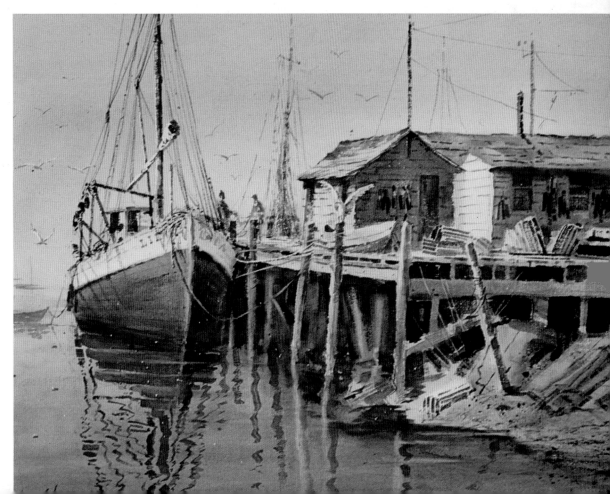

THE WHARF

GETTING READY

3. WAVES AT THE SHORELINE

A STUDY IN MONOCHROME

Before attempting to do sea-scapes in full color, it is not only helpful but almost imperative to first become adept in painting studies of waves in monochrome.

It is easier to develop a facility in painting various wave structures, forms, and movements in one color than trying to cope with all the nuances that complicate full color painting. The skill acquired can then later be applied to full color renditions with confidence.

I would also strongly advise doing these studies no larger than 10 by 14 inches. Confining the study to a small area not only makes it easier to see the entire picture but also minimizes the temptation to finish any one area before another. In working on a half or full sheet it is necessary to interrupt the painting procedure at short intervals to look at it in reverse in a mirror at a distance of from ten to fifteen feet in order to see the entire composition and values. This requires discipline and the less experienced painter is likely to become so absorbed in painting one area that he forgets to stop working on that part of the picture until it is too late. This is fatal to the painting since it is of the utmost importance to keep molding the picture over-all gradually.

On pages 23 and 24 are shown steps in monochrome painting of waves with painting procedures described. FISHING FOR STRIPERS reproduced on page 26 is an example of the shoreline painted in full color, to be tried only after having gained proficiency in monochrome.

Note: As an added help, on page 22 you will see a demonstration of how to diagram and paint waves in perspective. Always keep the horizon line and the vanishing point in mind.

A STUDY IN MONOCHROME
STEP-BY-STEP PAINTING PROCEDURE

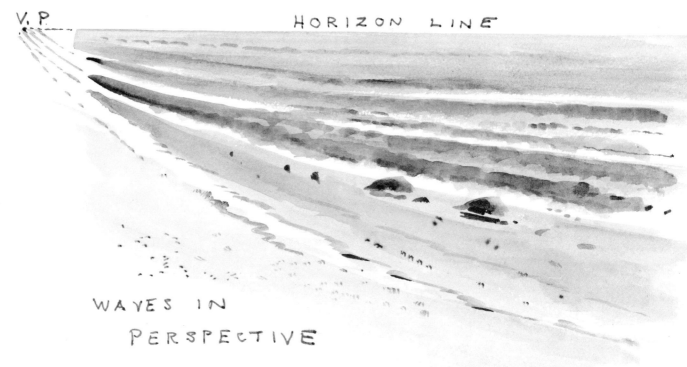

V.P.

HORIZON LINE

WAVES IN
PERSPECTIVE

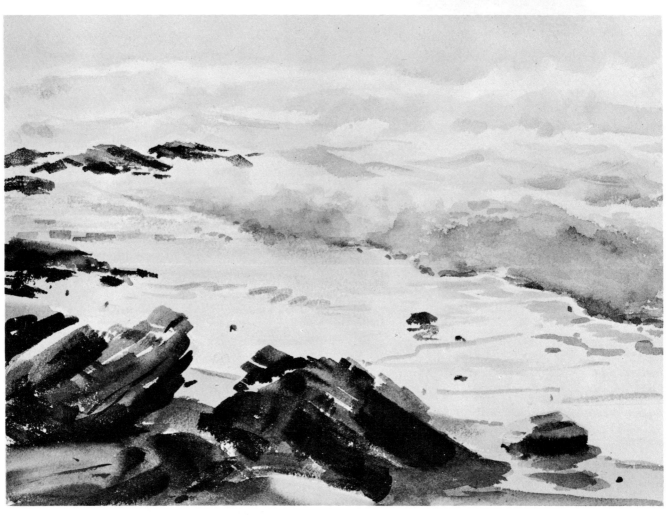

Waves in perspective.

Step 1. Indicate lightly in pencil the land area surrounding the water. Then, with Aquarelle brush, cover it with a light wash of any one color. Apply color in horizontal strokes.

Step 2. When dry, darken the land area using the Number 8 brush. Then with a light wash indicate the start of foamy surf in the center of the picture. Follow the painting.

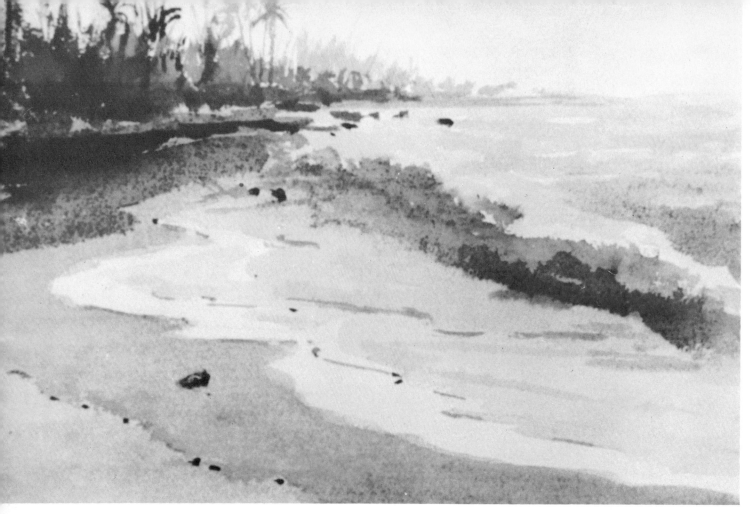

Step 3. With the Number 8 brush keep working on both sea and land areas from light to dark. Paint the trees in the background in drybrush. Then add accents.

Step 4. Continue to add accents and add reflections. Use a scratcher to soften the top of the breakers.

A STUDY IN MONOCHROME

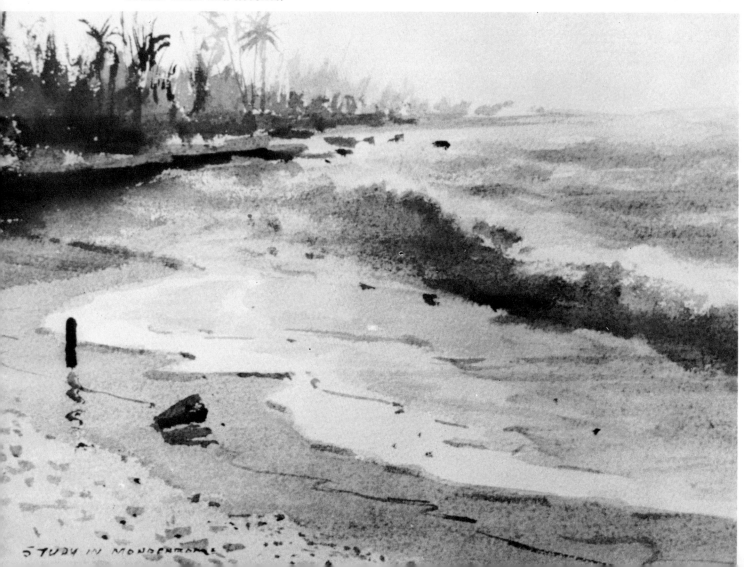

FISHING FOR STRIPERS

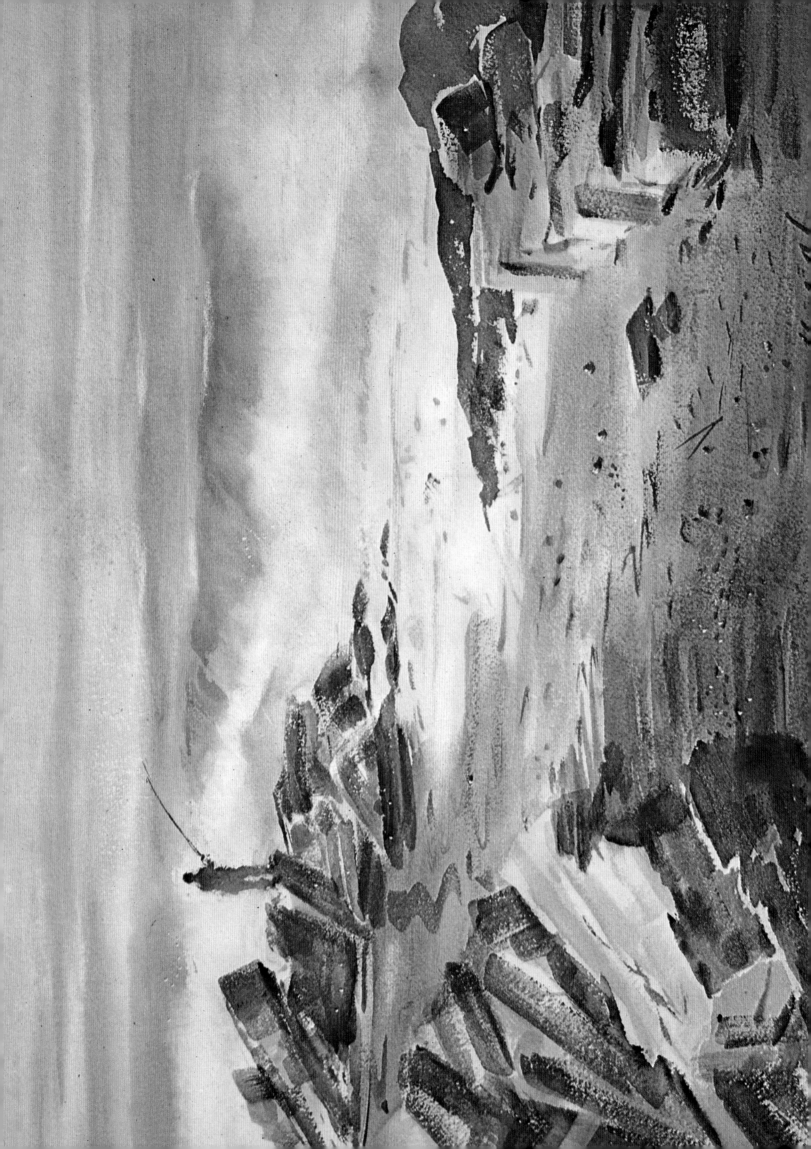

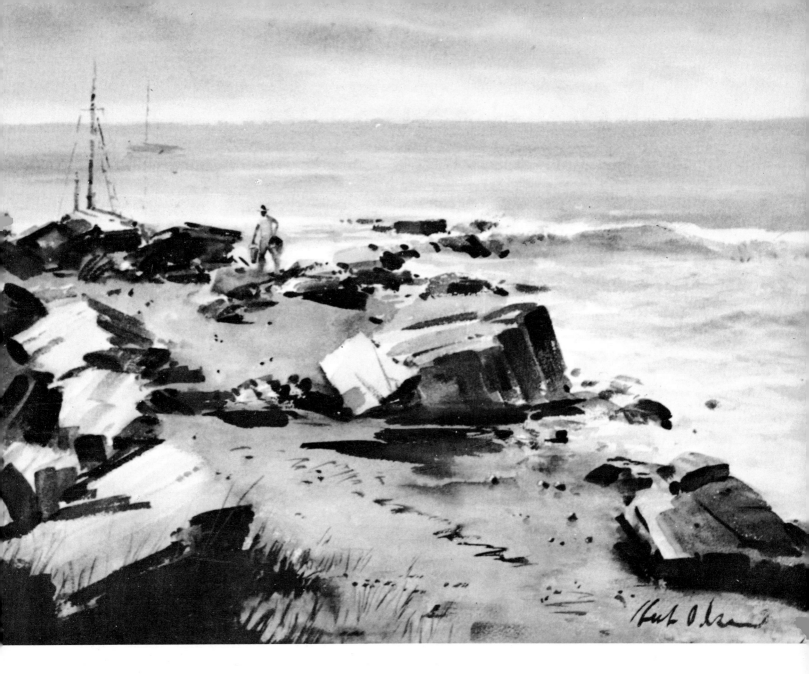

More Shoreline Scenes

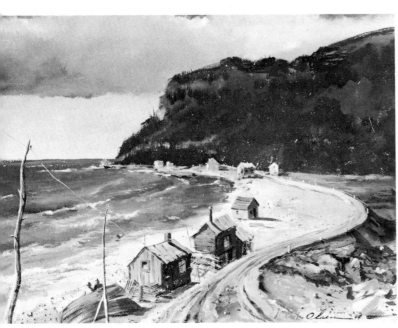

THE SHORELINE, GASPE PENINSULA, QUEBEC

WAVES AT LOW TIDE

4. ROCKS AND SURF

The compositions for these paintings were planned by the master planner—Nature. The handiwork of God is revealed in a very special way in the marine scene and presents us with so much beauty that it would be presumptuous to try to improve on it.

Painting the pattern of waters can only be done after much study. The action of the spray is so delicate that it is an absolute necessity to study it with eyes half-closed. The patterns then take on more definable forms, which are largely indistinguishable when looked at with eyes wide open.

Of course surfaces of rocks present an entirely different painting problem than the nebulous action of the waves and the swell of the sea breaking against the rocks, and the resulting foam or spray.

On the following pages you will see visual demonstrations of how I painted ROCKS AND SURF reproduced in color on page 35. Although the step-by-step lesson is for ROCKS AND SURF, BREAKERS, bottom page 35, was painted in the same manner. You will see that the fluid, soft portions are all painted with a sponge, and the hard surfaces of the rocks with brushes. I have painted many similar scenes using brushes only, but I have found that this combined method is the simplest and most effective one and have used it throughout the book where the paintings have like problems.

MATERIALS

PAPER:	D'Arches, 300 lb., full sheet (22 by 30 inches)
PENCIL:	HB
BRUSHES:	Aquarelle
SPONGE	
SCRATCHER	
COLORS:	Cobalt Blue
	Thalo Blue
	French Ultramarine Blue
	Veridian
	Sepia
	Burnt Sienna
	Orange

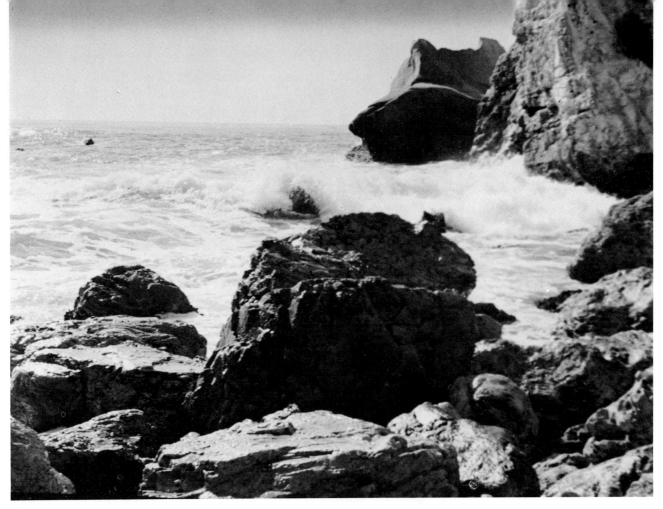

Photograph of rocks and surf.

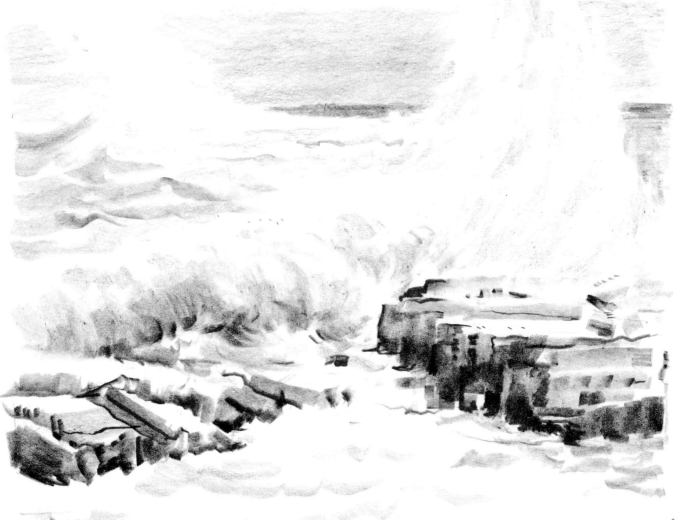

PENCIL SKETCH FOR THE BREAKERS

Pencil Sketch for BREAKERS, page 35.

Paint foam, spray, and fluid areas of water with a sponge.

Put in accents with a brush.

Paint the pattern of water with a brush.

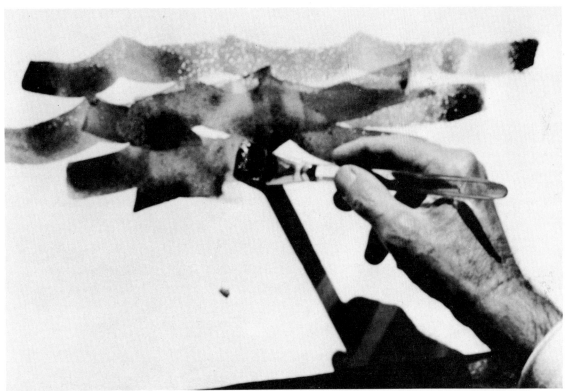

Paint rocks and other hard surfaces with a brush.

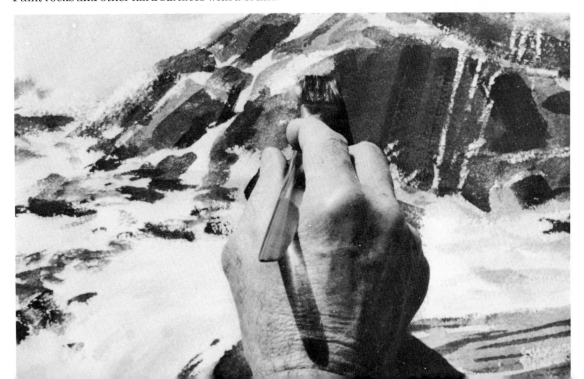

ROCKS AND SURF
STEP-BY-STEP PAINTING PROCEDURE

Step 1. Make a pencil drawing for placement of the rocks. Do not wet the paper before starting to paint.

Using a sponge, mix Cobalt Blue and a very light touch of Sepia on the palette and paint around the foamy area in the background, which is paper left white. Use darker notes of Cobalt Blue and Sepia with Veridian added to the sponge for the top of the breaker, blending into Orange at base of the wave between the upper two rocks. When dry, soften edges with a clean damp sponge.

Step 2. With the Aquarelle brush paint rocks with a very light wash of Thalo Blue, French Ultramarine Blue, Burnt Sienna, and Orange, mixed on the paper. Some of this color becomes the wet areas on the rocks not covered by dark color. Now paint the middle dark areas of rocks using Sepia, Burnt Sienna, and Orange, mixed on the paper. Then add a few darker areas with deeper tones of the same colors. Follow the painting reproduced on page 35, top. By mix-

ing colors on the paper a less static effect will result than if the colors were mixed on the palette.

Step 3. With same brush paint rushing water in the middle area around the rocks, using Cobalt Blue and a little Burnt Sienna mixed on the palette. When dry add Orange very lightly in the falls in the foreground. Follow the painting.

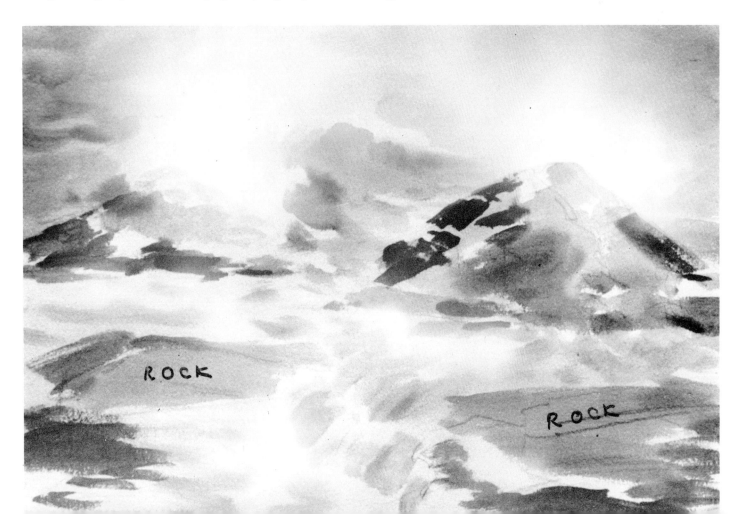

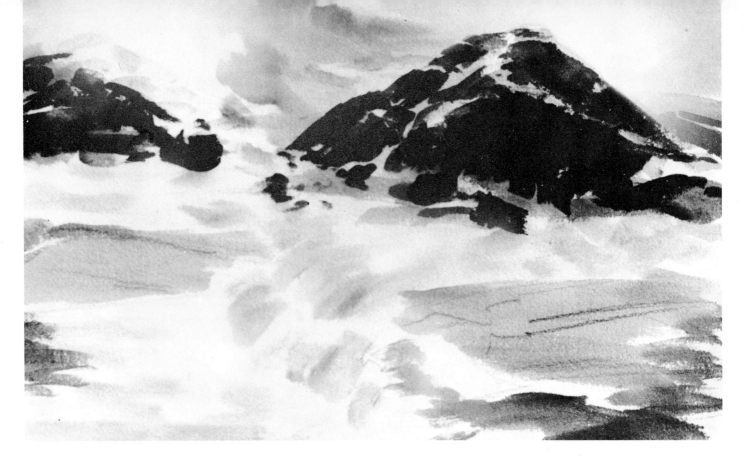

Step 4. Paint the rocks in the foreground with Sepia, Veridian, French Ultramarine Blue and Orange, mixed on the paper. Do not paint over the entire area—leave some underpainting showing for light water areas. See Step 2.

Step 5. Add accents in the foreground water areas, using Cobalt Blue and a little Sepia mixed on the palette. Apply color with the Aquarelle brush in the rushing water area and with sponge in the lower foreground pool area.

For final touches, accent the rocks using Sepia and Thalo Blue mixed on the palette. Follow the painting. When dry, use a scratcher for the tiny rivulets on the rocks.

It is of the utmost importance to remember to change your water frequently, especially after painting the dark areas. A good rule to follow at all times is to change your water just as soon as it becomes a color. Unless this is done, a muddy painting will be the result.

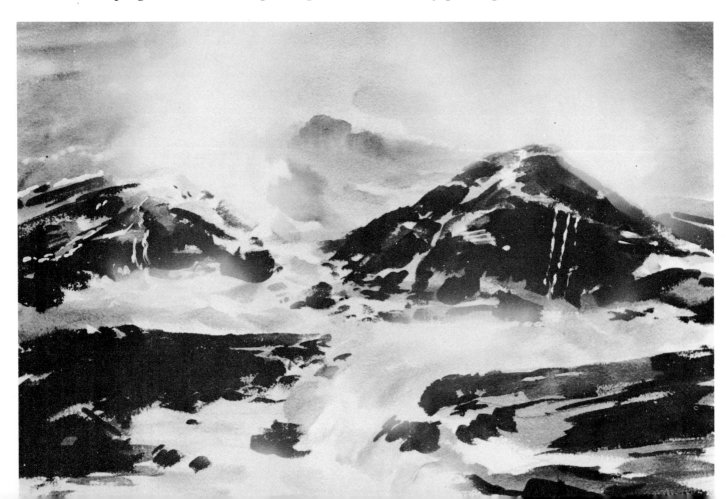

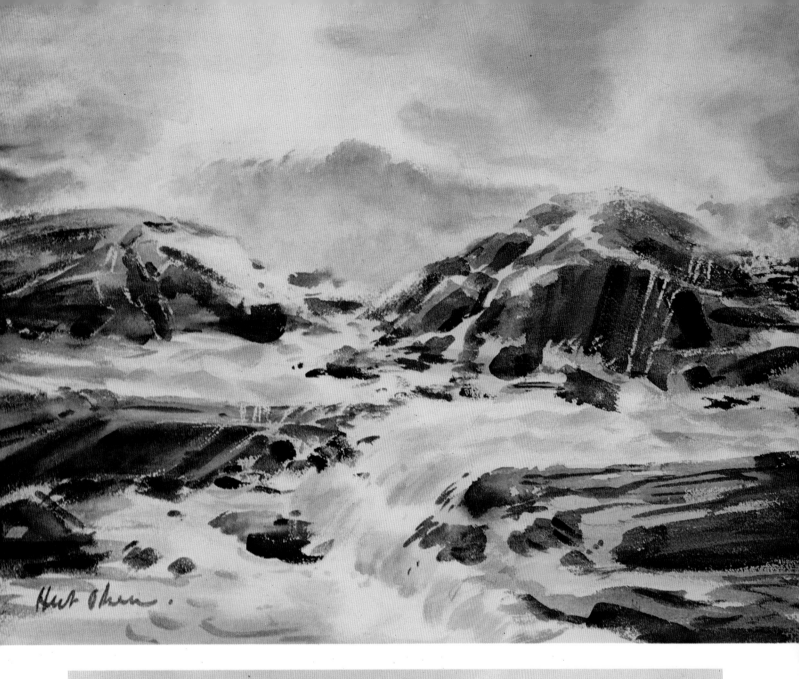

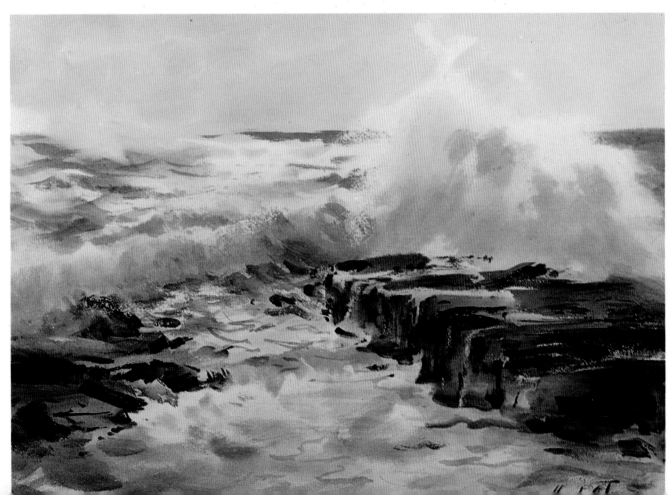

ROCKS AND SURF

BREAKERS

5. FISHING ON THE RIVIERA

About ten miles east of Marseilles, France, lies the beautiful fishing village of Cassis where I gathered the material for the picture reproduced in color on page 45. Cassis is still an unspoiled town that does not attract the average tourist probably because it is so quiet and peaceful with not too much to do but watch the fishermen—which is just what I did.

The town is indescribably picturesque with its high rocky cliffs, coves, colorful old buildings, and countless fishing craft and fishermen. I would have liked nothing better than to linger here and I hope to return some day to bask in its peace and beauty and savor its delicious wolf-fish which is the main fish caught in this area by fishermen such as those seen in the painting FISHING ON THE RIVIERA, reproduced in color on page 45. The step-by-step painting procedure follows.

MATERIALS

PAPER:	D'Arches, 300 lb., 28 by 20 inches
PENCILS:	HB
BRUSHES:	Numbers 8 and 12
MASKOID	
SPONGE	
COLORS:	Ultramarine Blue
	Antwerp or Thalo Blue
	Cobalt Blue
	Hooker's Green
	Sepia
	Burnt Umber
	Burnt Sienna
	Yellow Ochre
	Lemon Yellow
	Orange
	Black

FISHING ON THE RIVIERA
STEP-BY-STEP PAINTING PROCEDURE

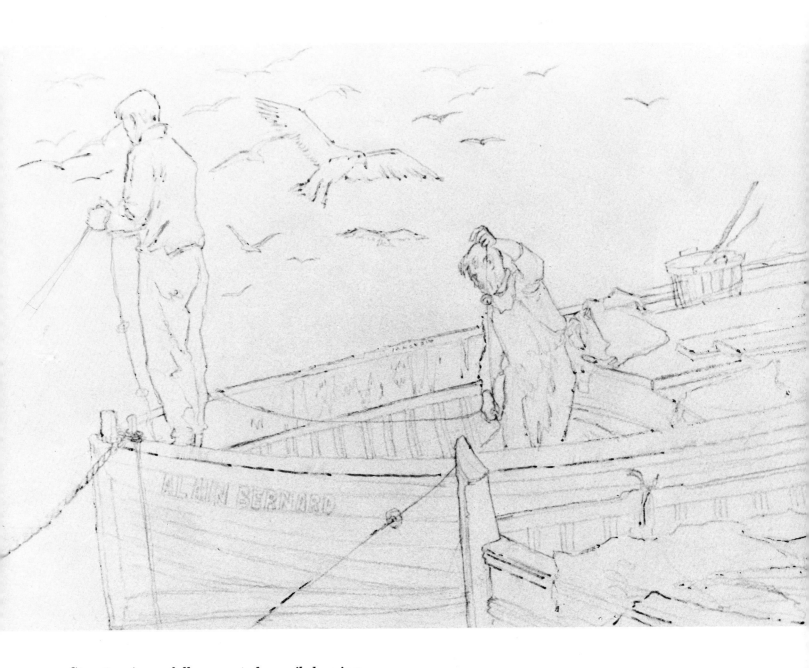

Step 1. A carefully executed pencil drawing.

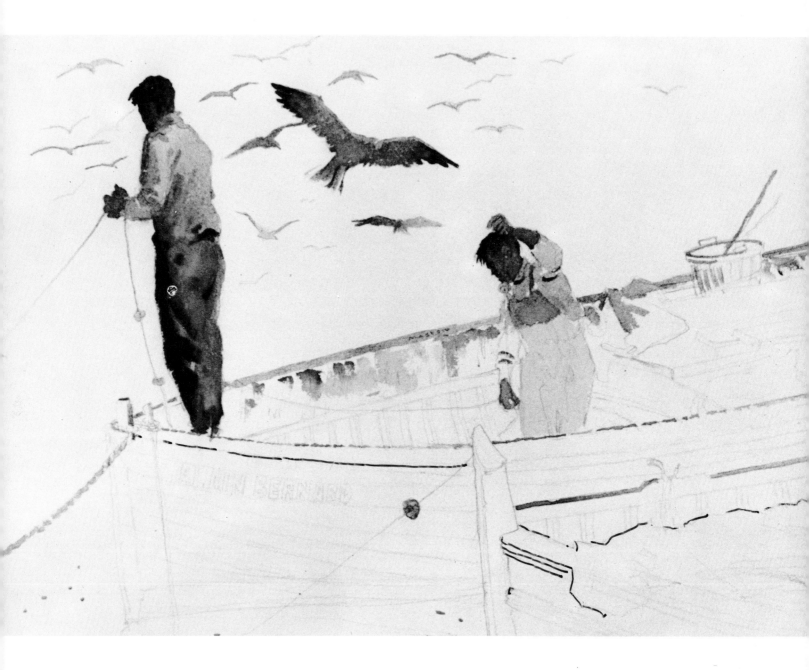

Step 2. Paint a very light wash of Burnt Sienna on the hands and face of the two figures, and let it dry. Then lightly paint the clothing. On shadow areas of the white shirt on the figure to the left, use Yellow Ochre. For the pants, first paint them with Lemon Yellow, and then for shadow areas add Sepia and Lemon Yellow mixed on the palette. For the figure on right paint a wash of Lemon Yellow on the overalls.

Paint the large gull, using Burnt Sienna and Cobalt Blue mixed on the paper. Leave paper white along the top edges of the bird. Then paint the wing tips with Sepia, Antwerp Blue, and Burnt Sienna mixed on the paper.

(For additional help see painting of Step 4 on page 42 showing the painted areas after the Maskoid has been removed. This clearly shows what areas are to be painted here in Step 2.)

Now when painting is dry, apply Maskoid to the figures, the large gull, the top of the boat, and add small gulls. Allow to dry thoroughly. Follow the painting of Step 2, opposite, as a guide as to where Maskoid is applied.

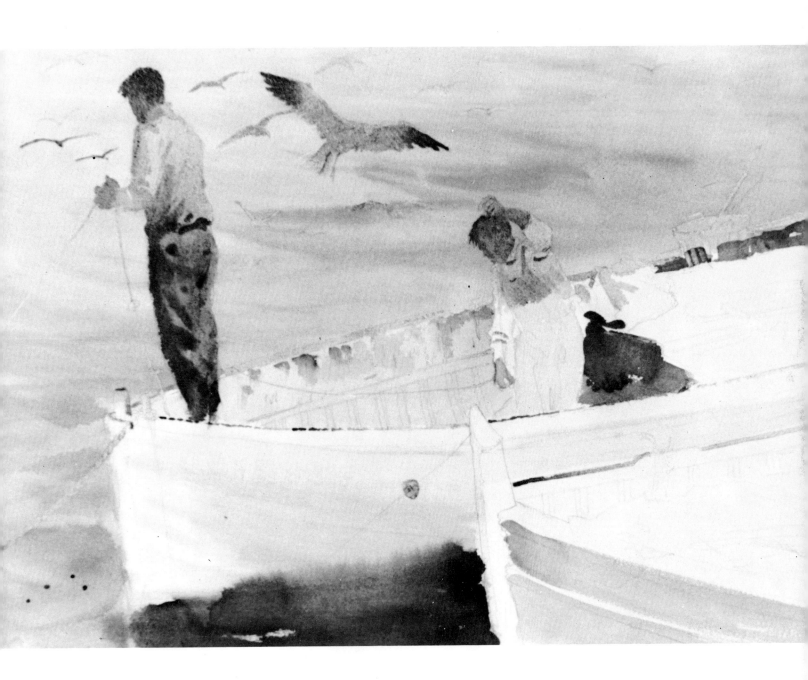

Step 3. Paint the sea with a fairly moist sponge, using Ultramarine Blue, Antwerp or Thalo Blue, Hooker's Green, and a little Sepia, Yellow Ochre, and Orange. This is applied in long horizontal strokes over the figures, the gulls, and in the foreground. Accents are applied with a large round sable brush while the painting is still moist. Let dry.

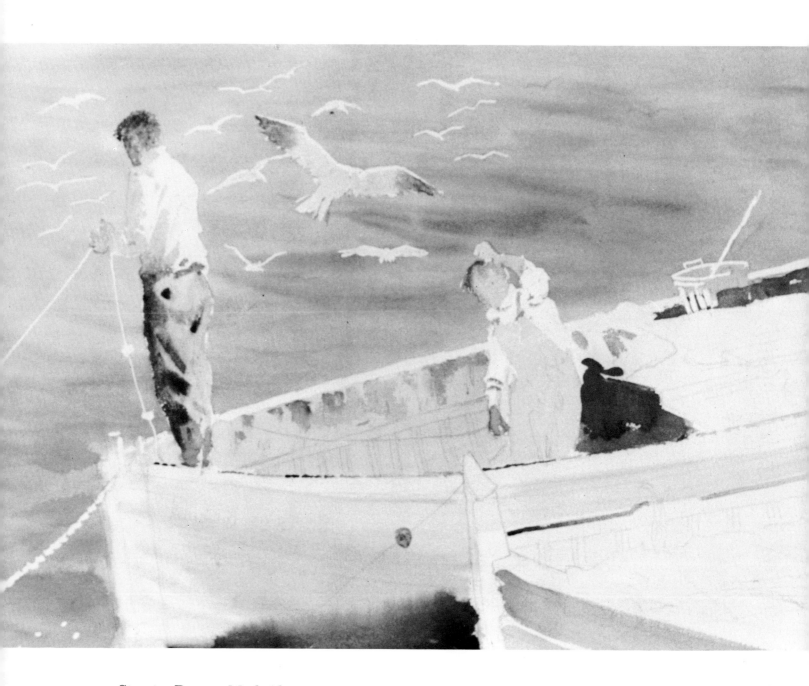

Step 4. Remove Maskoid.

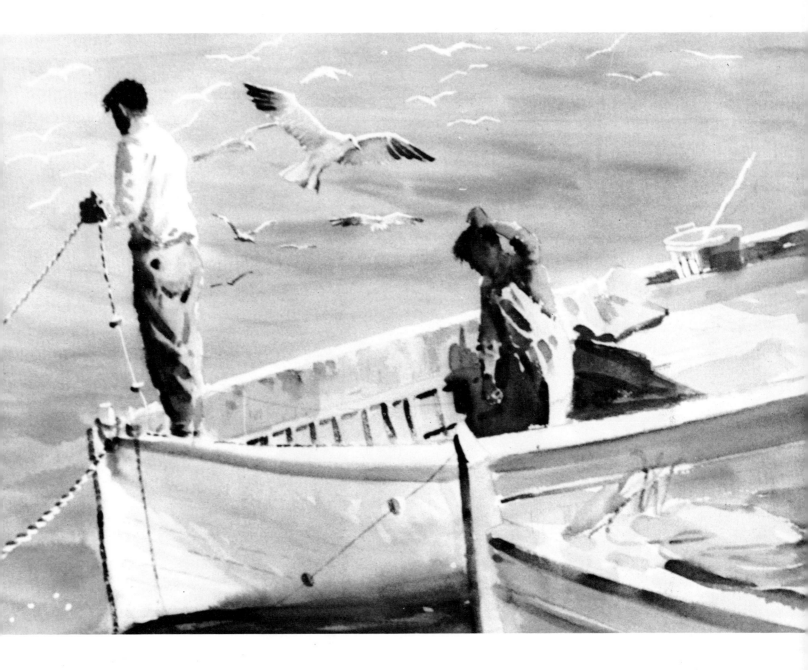

Step 5. Repaint the large gull with Burnt Sienna on the body melding into Cobalt Blue to Sepia on wing tips. Accent feathers with Cobalt Blue.

For the figure on left, paint the head with a light wash of Burnt Sienna. While damp paint the hair and shadow areas with Sepia. Then add Black mixed with Sepia to the hair. All of this is mixed on the paper. For the pants use a light wash of Lemon Yellow. Then, while damp, add Sepia and Lemon Yellow mixed on the palette. Add a touch of Orange at the ankle. When dry accent with Thalo Blue and Sepia mixed on the palette.

For the figure on right use the same colors for head and hands as in the other figure. When dry put a light wash of Thalo Blue over the head. When dry add Black to the hair.

The oilskin over-alls are painted with Lemon Yellow. Then add Burnt Sienna and Sepia mixed on the paper, and then add Thalo Blue. The shirt is Black and Ultramarine Blue painted thinly, and while damp darker notes are added using the same colors. When dry add accents.

For the large boat, use a Number 12 brush and paint shadows with Orange and Cobalt Blue. The smaller boat is painted with Cobalt Blue and Burnt Sienna.

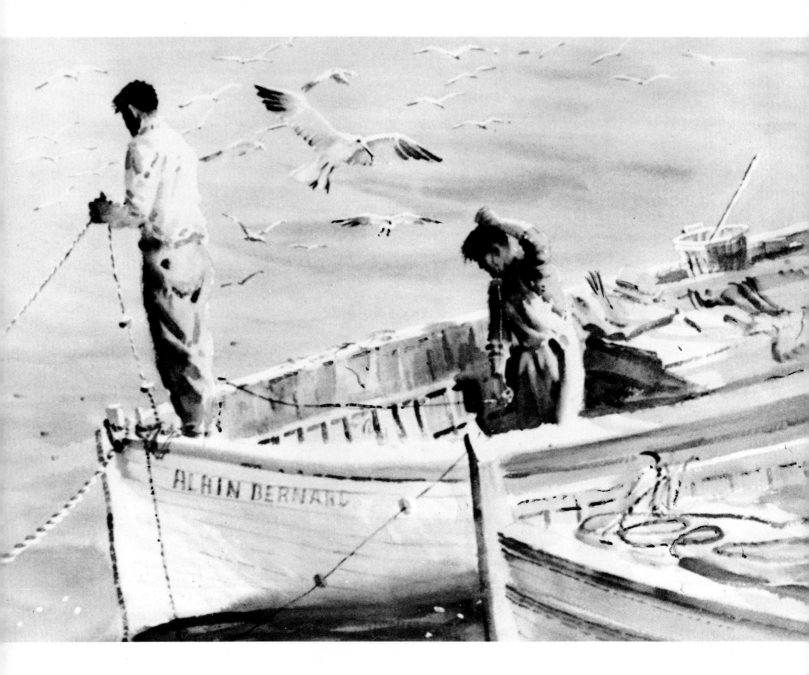

Step 6. Add details such as ribbing on the
boat, ropes, and accents as indicated. Follow
the painting reproduced opposite.

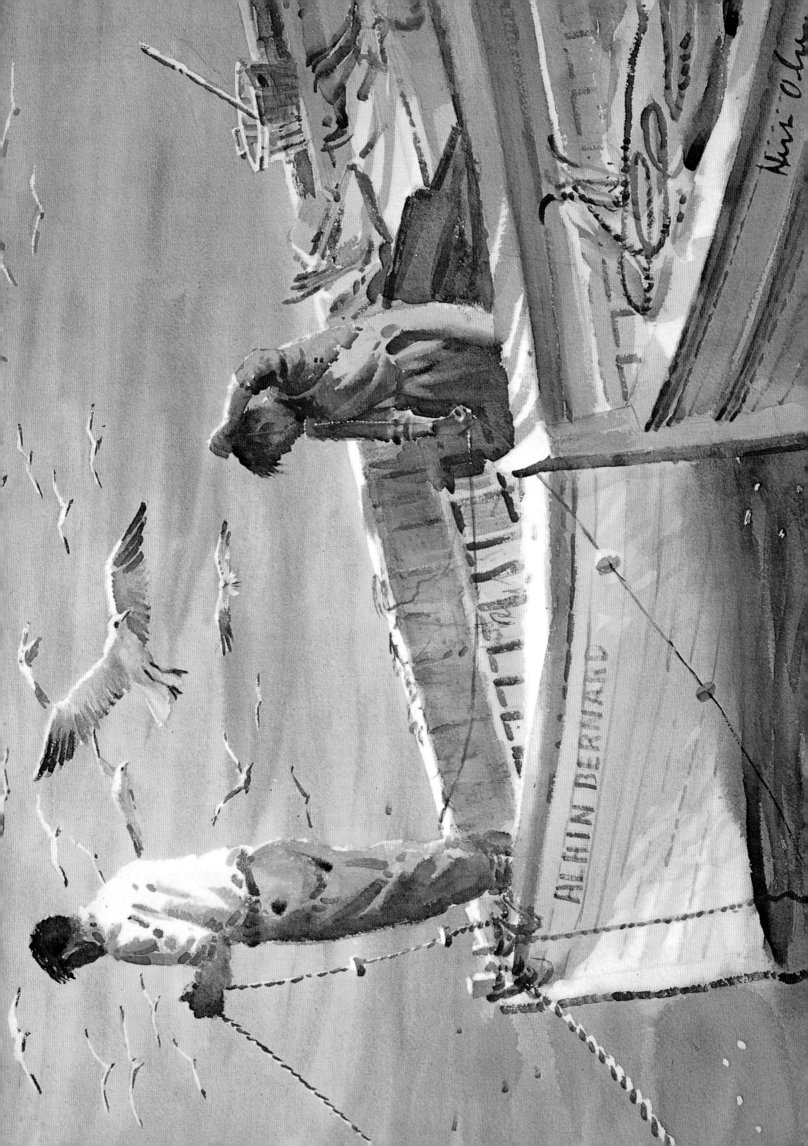

FISHING ON THE RIVIERA

6. THE WAVE

A wet sheet and flowing sea,
A wind that follows fast
And fills the white and rustling sail
And bends the gallant mast.
Allan Cunningham

Since it is my privilege to live near the sea I am in the fortunate position of being able to study it in its many moods. The charcoal sketches and color notes from which my painting was made were done on a particularly rough day when the waters were echoing the turbulence of a distant hurricane.

The similarity in construction of a wave and mountain has been compared by poets and artists alike. Francis Alan Ford calls the waves "Wandering purple mountains capped with peaks of fleecy snow." To prove how right he is see the charcoal sketches of waves and the sketch of a mountain on page 50. Notice that each is based on a series of triangular shapes. First comes the large shape, and this is then broken up into smaller triangles and rivulets. The difference between the mountain and the wave, of course, is the softness of the latter. This fluidity is achieved in painting by eliminating all hard edges with a sponge. In THE WAVE, reproduced in color on page 52, the sky and water were painted with a sponge and accented with the Aquarelle brush. The boat was painted with a Number 8 brush. A complete list of the materials I used are given opposite.

Study the diagrams on pages 48 and 49 before you attempt to paint a wave.

MATERIALS

PAPER:	D'Arches, 300 lb., full sheet (22 by 30 inches)
BRUSHES:	Aquarelle, Number 8
SPONGE	

COLORS:
FOR THE SEA

MIXED ON PAPER
{
Viridian
French Ultramarine Blue
Lemon Yellow
Sepia
Burnt Sienna
Thalo Blue
}

FOR THE BOAT

MIXED ON PALETTE
{
Mauve
Yellow Ochre
Sepia
Indian Red
Burnt Sienna
French Ultramarine Blue
}

FOR THE SKY

MIXED ON PALETTE
{
Yellow Ochre
French Ultramarine Blue
Indian Red
}

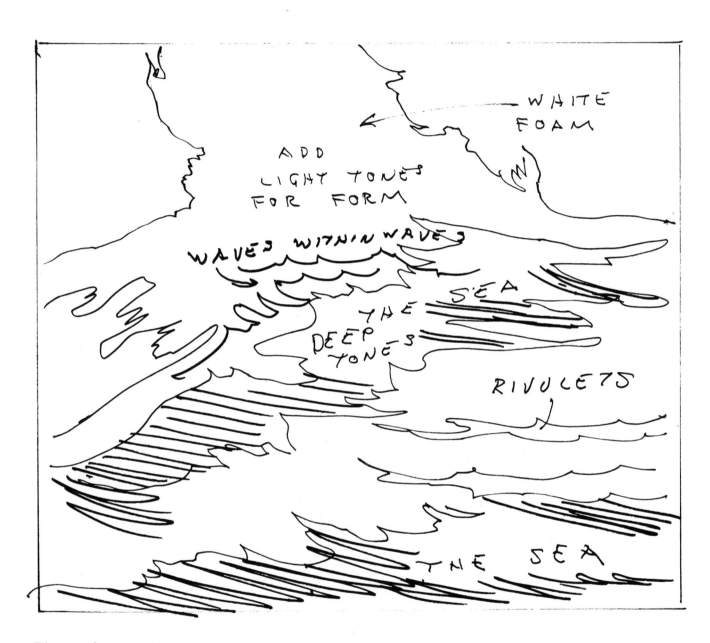

Diagram of a wave.

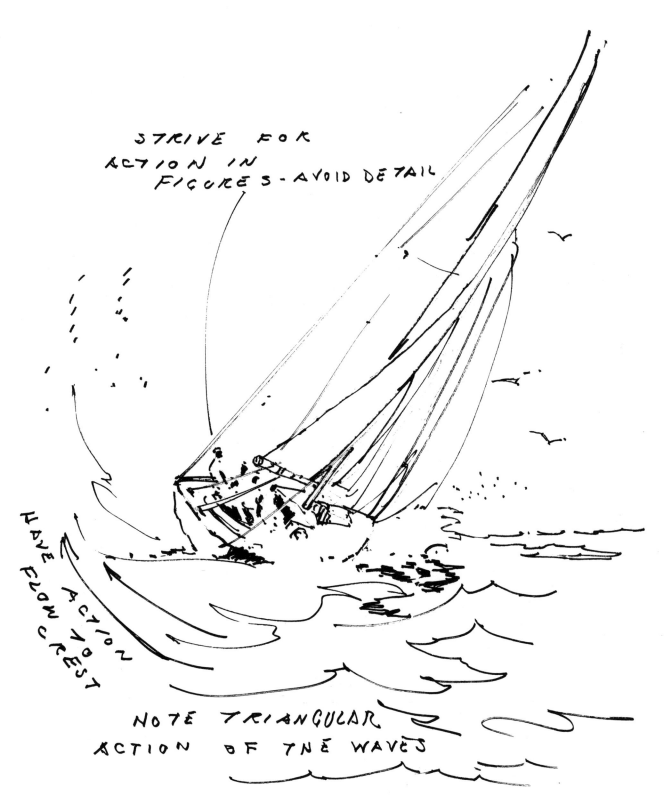

STRIVE FOR
ACTION IN
FIGURES - AVOID DETAIL

HAVE ACTION
FLOW TO CREST

NOTE TRIANGULAR
ACTION OF THE WAVES

Interaction of waves and a sailboat.

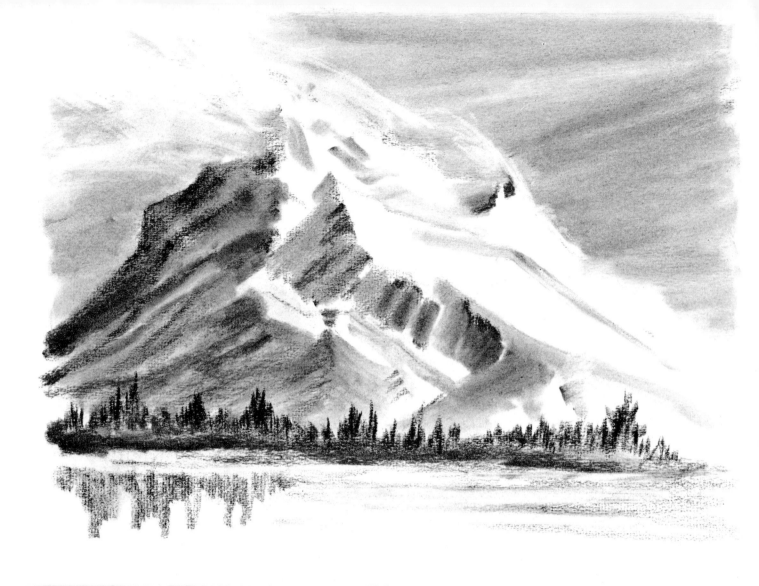

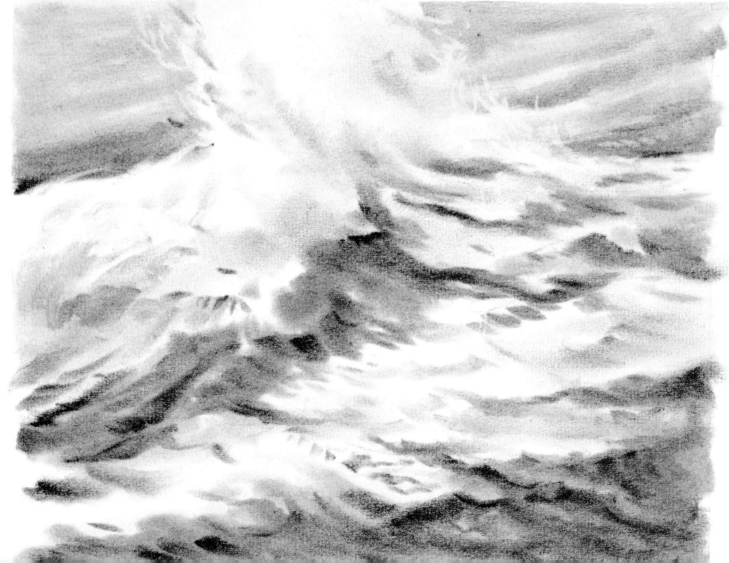

Charcoal sketch of a mountain.

Charcoal sketch of a breaker. Detail.

THE WAVE

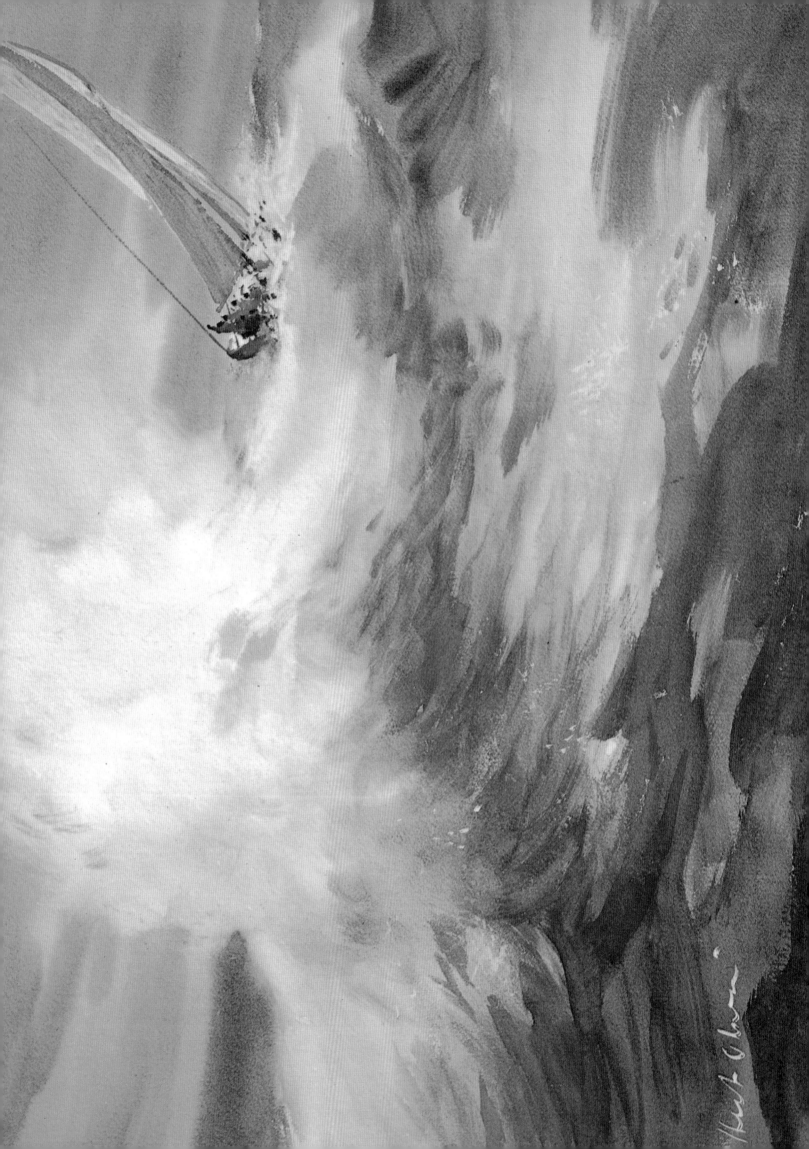

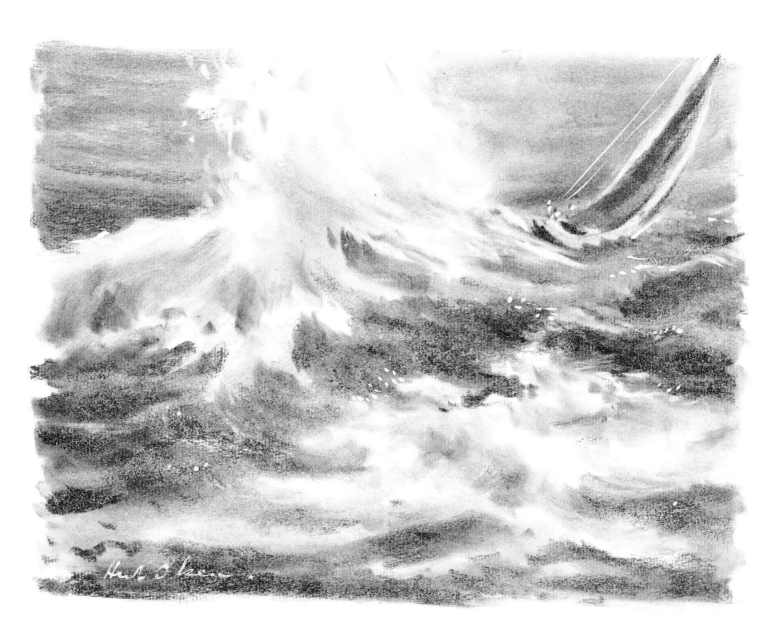

Charcoal sketch for THE WAVE, opposite.

7. THE FISHERMEN

The fisherman goes out at dawn
When everyone's abed
And from the bottom of the sea
Draws up his daily bread.
Abbie Farwell Brown

It has been my good fortune to have travelled extensively and on my travels I have painted almost every type of fishing vessel that exists in North America. On a trip to the Oregon coast a few years ago I saw, for the first time, salmon boats and their crews in action. The data—photographs and sketches I made at the time—were filed for future use.

THE FISHERMEN, the picture that resulted, was painted in the same manner that I use in all of my paintings—first working from several rough compositions to find out which one appealed to me most. Five of my roughs are shown opposite. On page 56 is the final pencil drawing, with color notations. The finished painting is reproduced in color on page 57.

This painting won the $1,000.00 Edwin Palmer Memorial Award for a Marine Painting at the National Academy of Design in 1964. It is now in the collection of Mr. E. C. McCormick, Jr. of Akron Ohio.

The Fishermen
(The First Roughs)

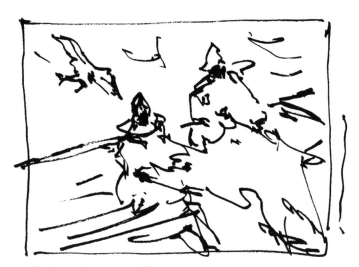

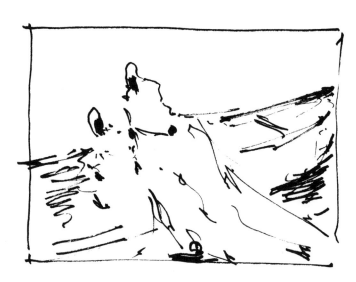

Finding the composition.

I USED THIS ONE

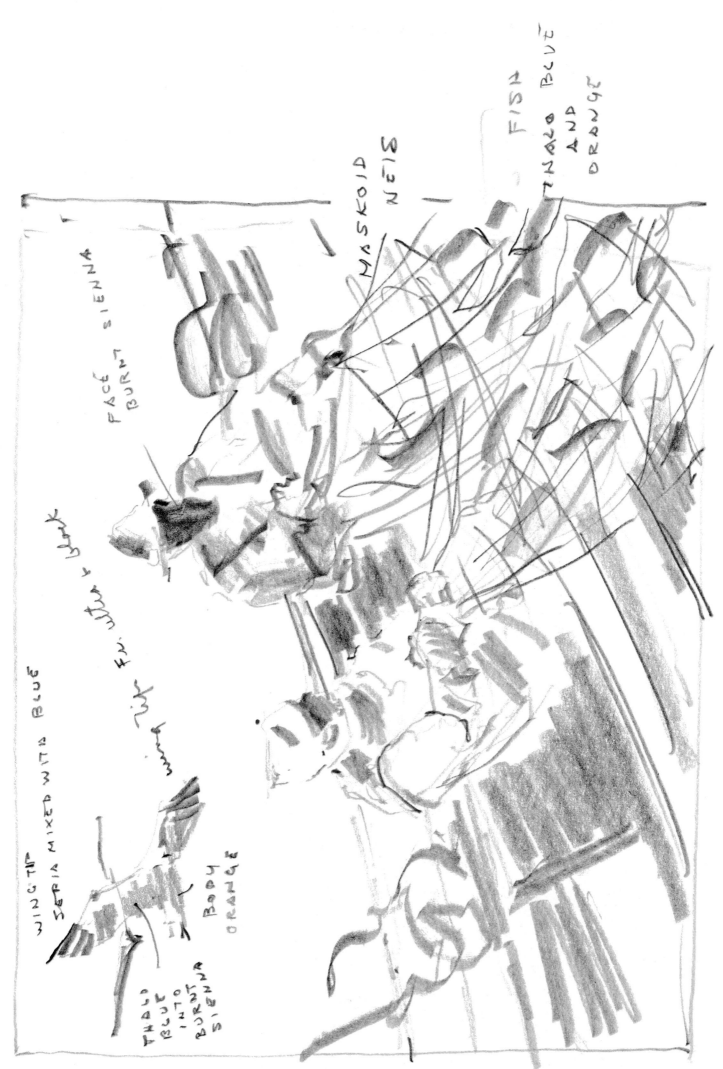

Pencil sketch for THE FISHERMEN, opposite.

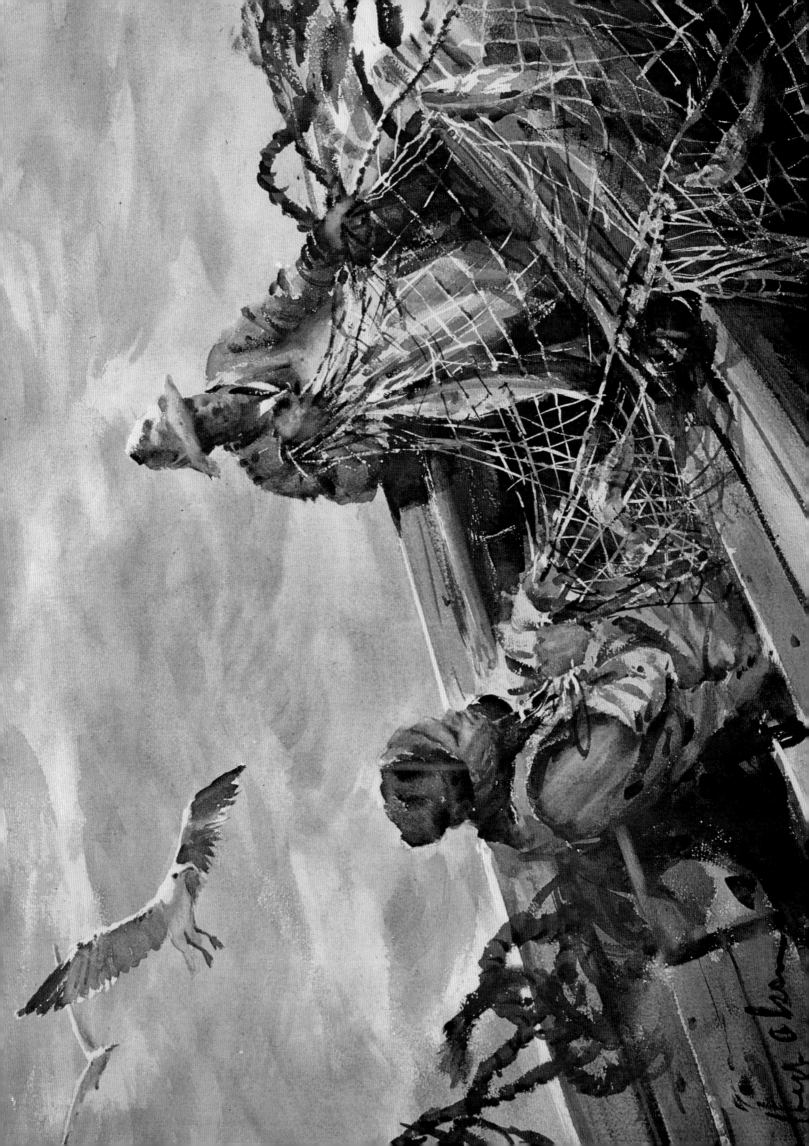

THE FISHERMEN

OYSTER FISHERMEN

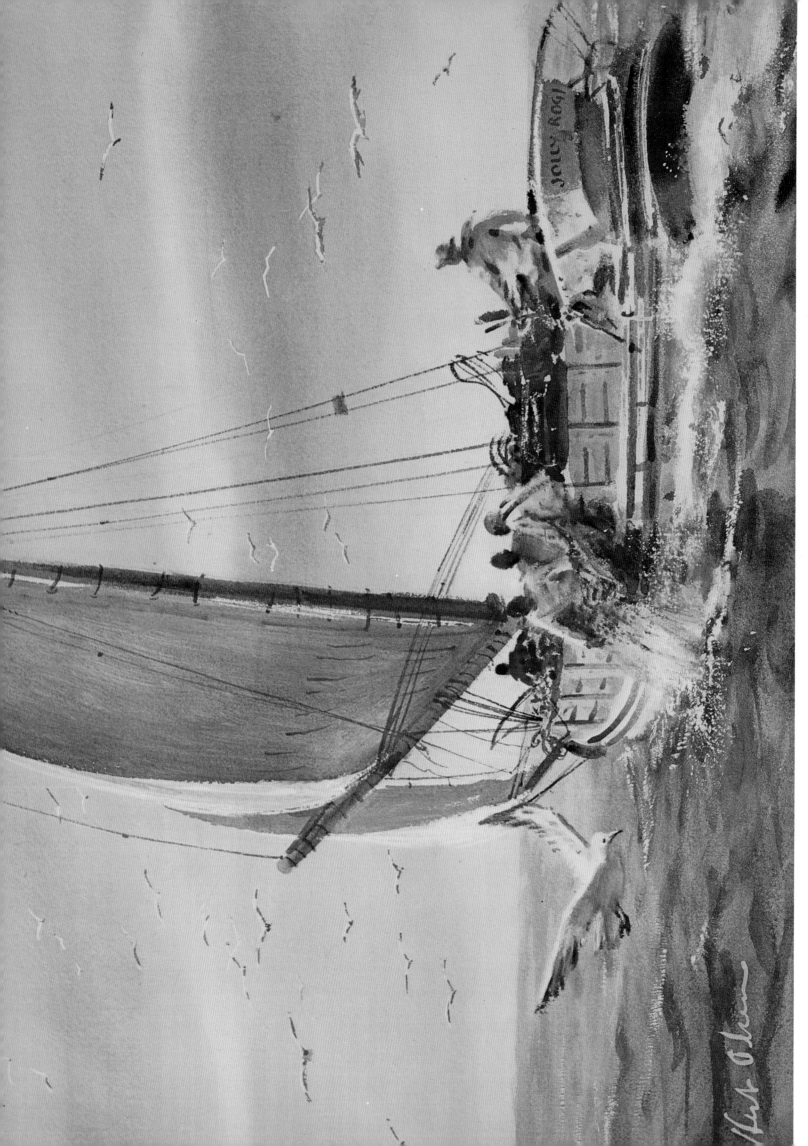

8. OYSTER FISHERMEN

Because in Chesapeake Bay the boats that work the oyster beds must, by law, be without power, it presents a setting for the artist that is rare and colorful and no doubt short-lived in this rapidly changing world of automation. The sailing vessels do carry a small motor boat on davits at the stern. If becalmed, the captain puts this boat in the water and, starting the engine, lets it push the sailboat back to dock. With artistic license I eliminated the motor on the auxiliary boat in the painting reproduced opposite.

The fact that all oyster dredging must be done under sail is in no small measure responsible for the preservation of sailboats on this picturesque bay. But, picturesque as the high point of hauling in the catch is, there is a great deal more to the oyster fisherman's job than meets the eye here. Part of his job is to cultivate the oyster beds. Among other duties, starting a year after they are spawned, the fishermen must hoist the baby oysters into boats and move them to a different body of water each year for four to six years, because oysters become misshapen unless frequently transplanted.

Another one of the fishermen's many chores is to protect the animals from their natural enemies—in northern waters particularly the starfish, which actually eat millions of young oysters each year, often destroying a large part of the year's crop. Fishermen drag starfish "mops" over the oyster beds to entangle the pests, then haul them aboard the boat where they are given the boiling water treatment which quickly ends their careers. Fishermen must exercise constant vigilance to prevent overwhelming damage.

Men of the sea have been harvesting oysters for over two thousand years, for oysters have been a favorite delicacy as far back as 80 B.C. when they were exported from Britain to Rome for the hungry gourmets of that time. American Indians dried and smoked oysters as articles of barter with inland neighbors. Today, their popularity is increasing and oyster fisheries have become very important industries in many countries.

In this country oysters are harvested on both the Pacific and the Atlantic coasts; on the Atlantic coast especially in the waters around Long Island, the region of the Delaware Bay, and in Chesapeake Bay, the scene of my painting.

9. THE BUNKER FISHERMEN

A PERSONAL STORY

Some years ago, I believe it was in the late spring of 1954, I was invited by my friend, Commodore Clifton Hipkins of the Riverside Yacht Club, Connecticut, to witness a race of Q.A. 17's (class boat) in the Long Island Championship Race. I was to be a guest on the boat of the Chairman of the Race, Mr. Willis Fanning. It was not until much later that I learned that Mr. Fanning, when informed of this, was less than enthusiastic about the prospect of having a "long-hair" artist aboard.

Since the invitation could hardly be graciously rescinded, Commodore Hipkins prevailed on Mr. Fanning to have me aboard—welcome or not. The day was a dreary one and as we lazily moved about, I suddenly spotted a group of negro fishermen chanting and pulling rythmically on nets.

"What in heaven's name is that?" I asked my host excitedly. "Bunker fishermen," he replied. "What are they doing?" I asked. "Fishing for Menhaden," he answered. Not waiting to ask any more questions I reached for my Leica and within a few seconds Bill (we now were on first name terms) got into the spirit and had his boat close enough for me to take my photo-

graphs and, forgetting his duties for a few minutes, was fulfilling my every whim and desire.

Later I learned that Menhaden is a sea fish of the herring family common along the Atlantic coast and is used primarily rendered for marine fuel oil. The Menhaden are stored in large bunkers or tanks—hence the term "bunker fishermen." Seeing, for the first time, the unusual operation of net loads of the fish being hauled into boats by these happy, singing fishermen, and then, when their boats were filled to capacity, watching them bring the catch to the mother boat standing at anchor nearby—this was an experience that I had to paint. I painted the scene twice, and on pages 64 and 65 will be seen the pictures that were the result of a very exciting afternoon and the beginning of a long friendship. Mr. Fanning is the owner of several of my paintings and has a favorite rhyme he likes to quote:

"Some like picture o' women, said Bill,
"an' some likes 'orses best,
"But I likes picture o' ships," said he,
"an' you can keep the rest."

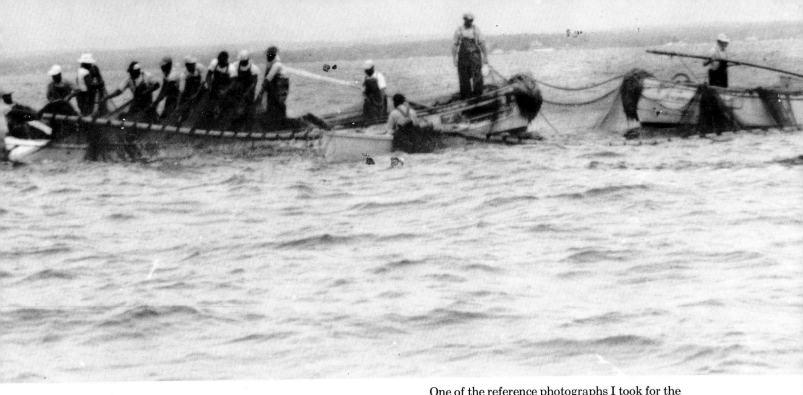

One of the reference photographs I took for the
Bunker Fishermen paintings, pages 64 and 65.

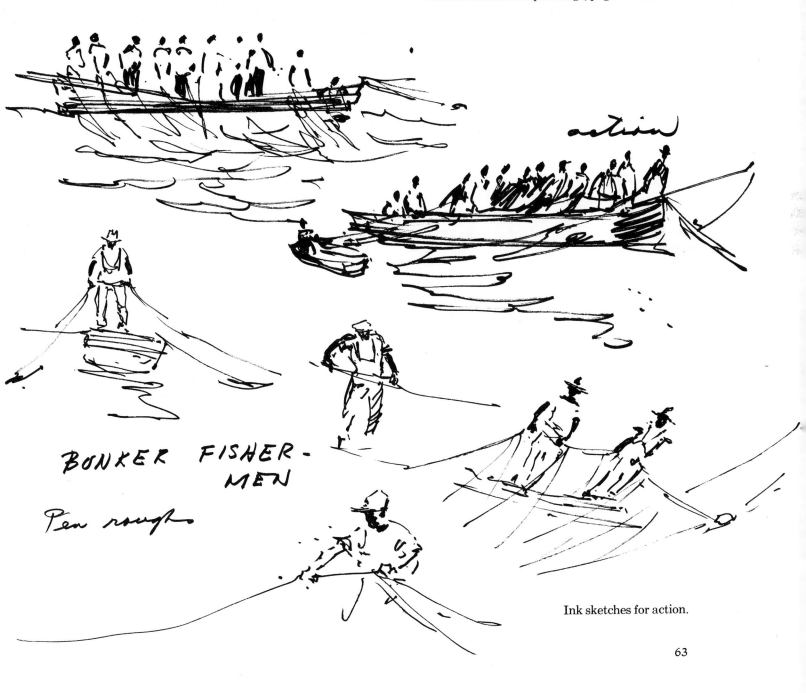

action

BONKER FISHER-
MEN

Pen roughs

Ink sketches for action.

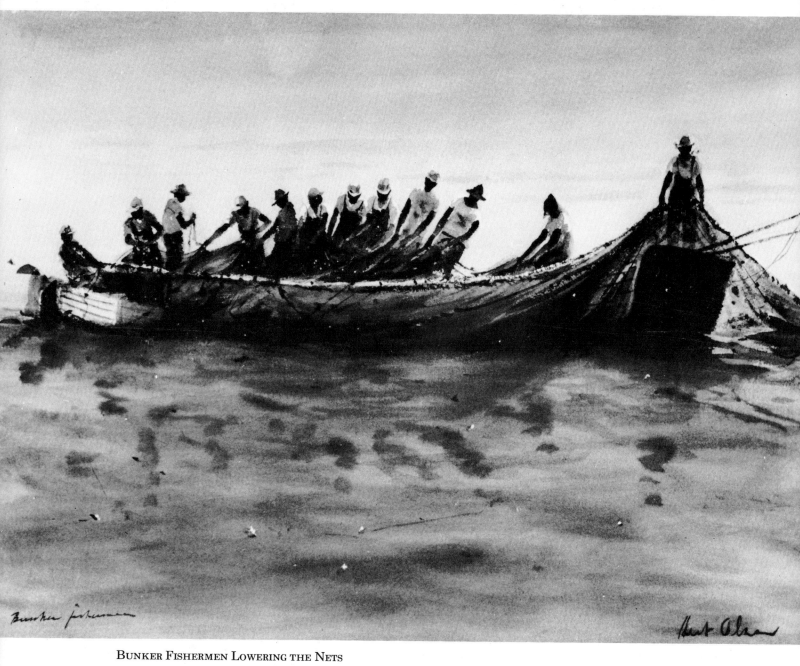

Bunker Fishermen Lowering the Nets

Reference photograph for DRYING THE NETS, opposite.

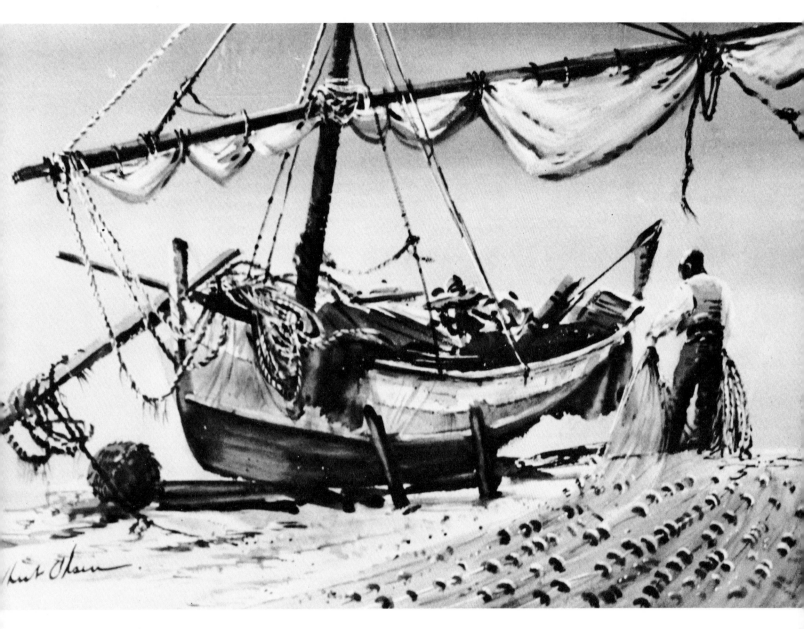

DRYING THE NETS

10. ROUGH WEATHER

The painting ROUGH WEATHER, reproduced opposite, is an example of a composition in which the sea as well as the boat is secondary to and dominated by a figure. Only a small portion of the boat is in the picture and a comparatively minimal amount of water is seen, yet the viewer is very much aware of both. It is a type of composition that obviously requires a knowledge of painting a large figure in watercolor and is not suggested for the amateur. However, for those of more experience I think it presents an exciting challenge.

Step-by-step painting instructions appear on pages 71, 72, and 73. Since this is a subject for advanced students, I have condensed the usual first steps into one. Opposite are the materials I used.

MATERIALS

PAPER:	D'Arches 300 lb., full sheet (22 by 30 inches)
PENCIL:	HB
BRUSHES:	Aquarelle and Number 8
MASKOID	

COLORS:	Antwerp Blue
	Rembrandt Green
	Sepia
	Burnt Sienna
	Mauve
	Yellow Ochre
	Permanent Blue
	Lemon Yellow
	Yellow Orange

ROUGH WEATHER

ROUGH WEATHER
STEP-BY-STEP PAINTING PROCEDURE

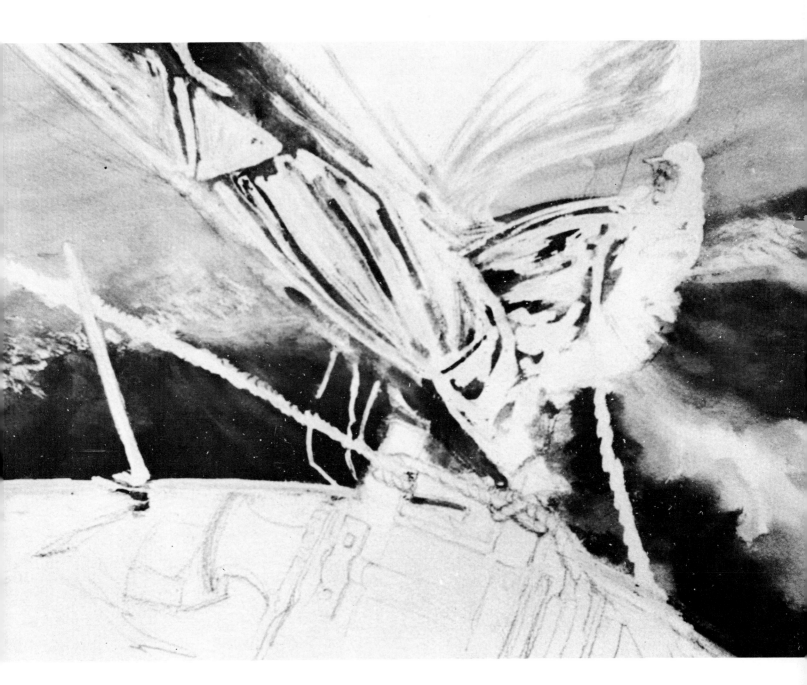

Step 1. After a careful drawing, Maskoid is applied to the figure, sail, and ropes. The sea is then painted over the figure and sail, using an Aquarelle brush and the following colors mixed on the paper: Antwerp Blue, Rembrandt Green, Sepia, and Burnt Sienna. Apply the color in broad strokes. When dry, remove the Maskoid and proceed with the following three steps.

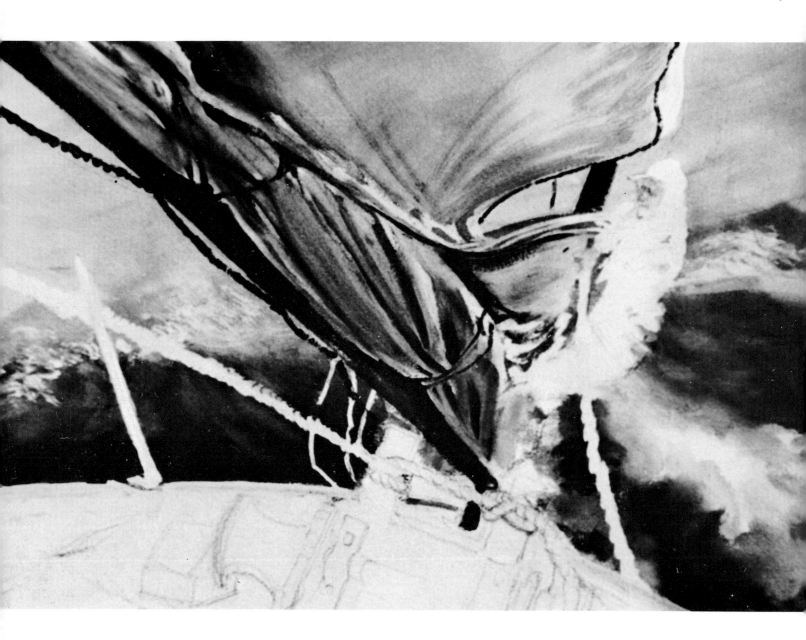

Step 2. Paint the sail with the Aquarelle brush, using Mauve, Yellow Ochre, and Permanent Blue, mixed on the palette. For darks use the same colors and add Sepia.

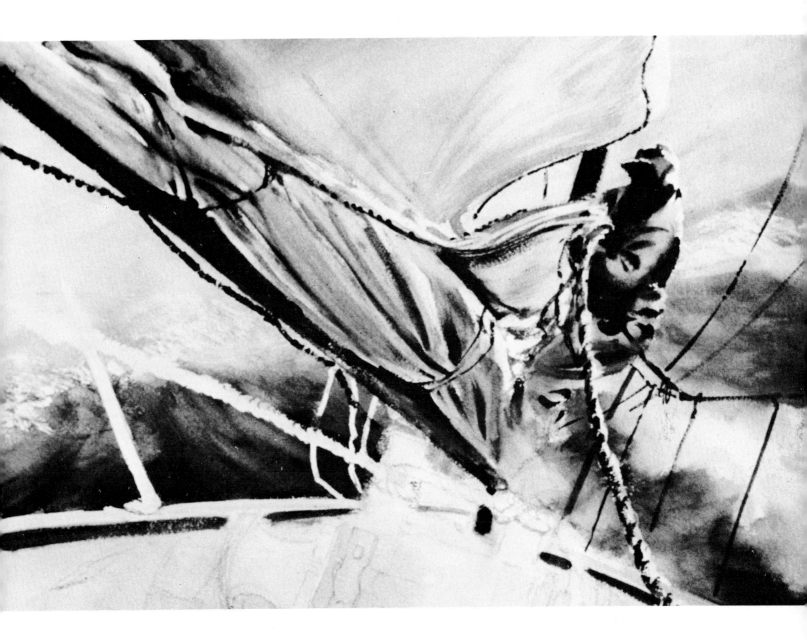

Step 3. Paint the figure with a Number 8 brush using Lemon Yellow and Yellow Orange mixed on the paper. For darks add Sepia to the same colors and mix on the palette.

Step 4. Follow the color reproduction on page 69 for finishing.

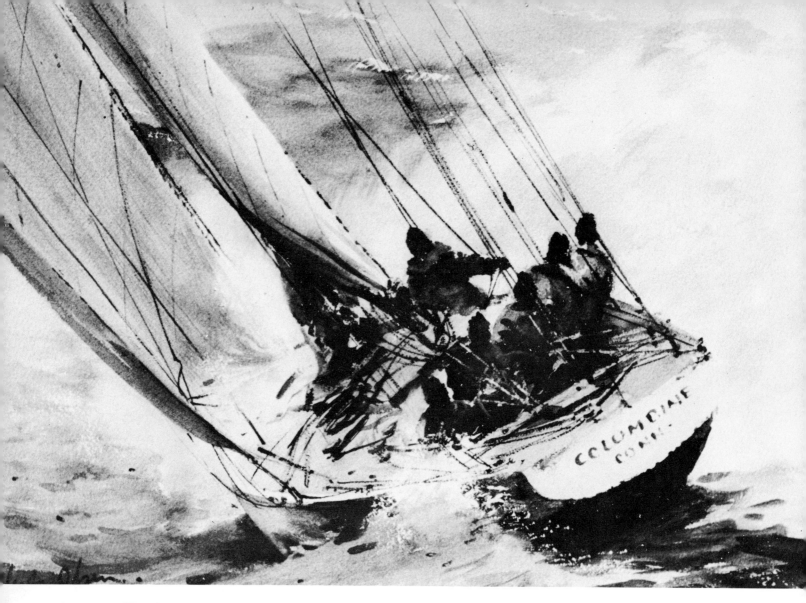

THE COLUMBINE

11. THE PLEASURE SAILING CRAFT

The pleasure sailing craft has a widely popular appeal to the sportsman and its beauty is an inspiration to the painter. Before one can authoritatively paint any type of boat, commercial or pleasure, it is essential to learn the correct rigging for the type of boat to be painted, just as the landscape painter must learn about trees, for example. The list of types of pleasure craft is a long one and there are many sources of information concerning them available to any student interested in the subject, but since we are primarily interested in painting them rather than in their nautical aspect, I will confine myself to mentioning the two types shown.

Reproduced in color on page 76 is a painting of a ketch entitled SATURN. The ketch is a sailing vessel with two masts, the foremast being the highest, carrying a jib and mainsail, while the aftermast, which is forward of the rudder, has only a small sail. On pages 77 and 78 are shown the preliminary sketches for finding and planning the composition, and the more detailed rough sketches made once the composition was established.

Above a picture of a sloop entitled THE COLUMBINE is shown. The sloop is a single mast vessel with fore and aft sails. This painting is reproduced in color on the jacket of this book.

THE SATURN

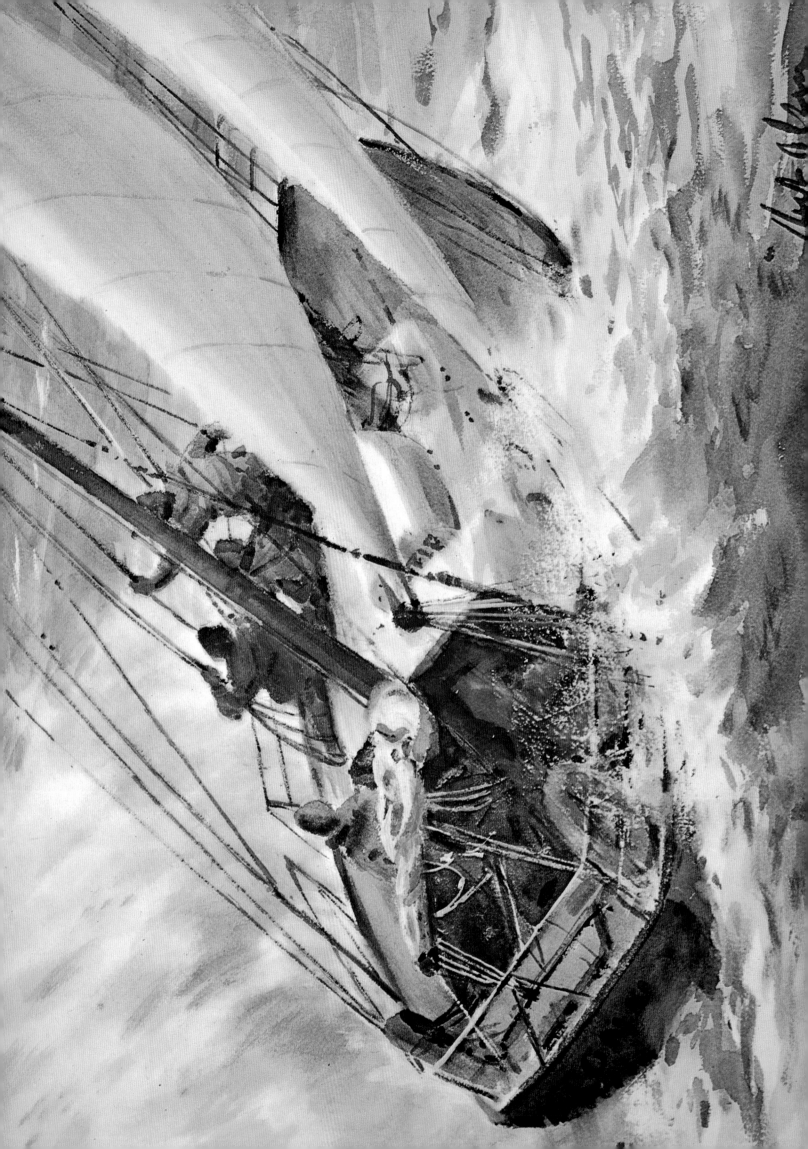

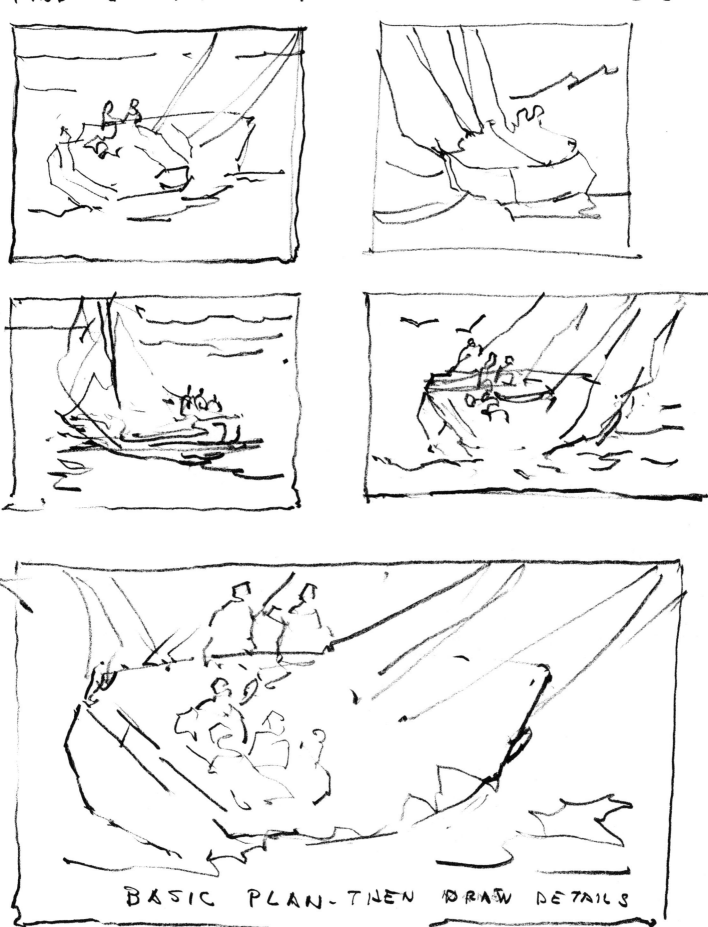

BASIC PLAN-THEN DRAW DETAILS

Pencil roughs for THE SATURN, opposite.

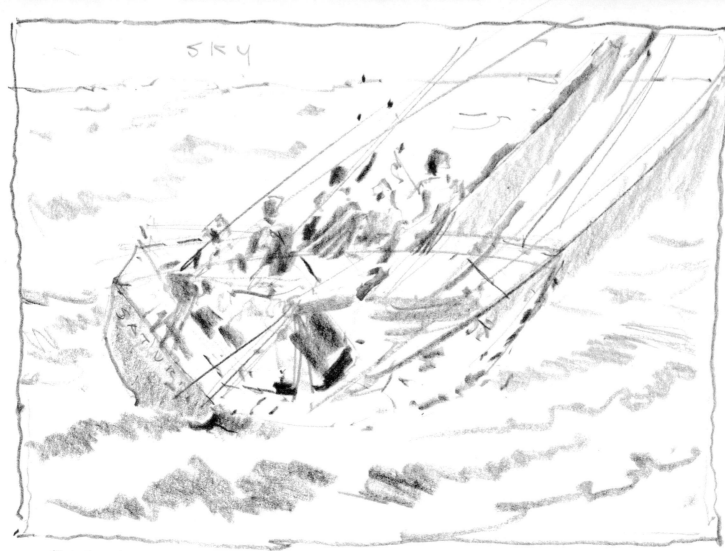

SKY

FIRST ROUGH - LACKS ACTION

Rough pencil sketches for the final composition.

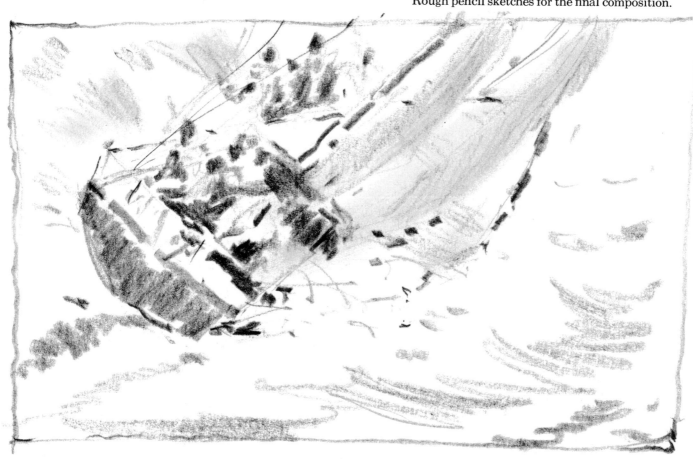

FINAL ROUGH - ELIMINATE SKY. TURN
BOAT SKYWARD.

12. FURLING

A marine painting does not necessarily have to show water. Docks, fishing equipment and gear, boats under repair, boats in dry dock, or portions of boats are all a part of the marine scene.

The composition for the painting FURLING was suggested to me several years ago when I ran across some pictures of the filming of "The Bounty" in Tahiti. I was fascinated by the action of the small figures on this giant vessel, hundreds of them furling sails. All sailors know that the purpose of furling is to reduce the area exposed to the wind by completely rolling up the sails. In case of severe storm or other emergency, the fearful cry of "All hands on deck" meant that everyone, even the cook (see the figure with the cook's hat on in painting), joined the hazardous chores.

From these clippings I made several action sketches (see pages 80 and 83). I felt that trying to do the whole ship would be less dramatic than painting a small portion of it to show the action of the procedure. The finished painting is reproduced in color on page 82.

furling

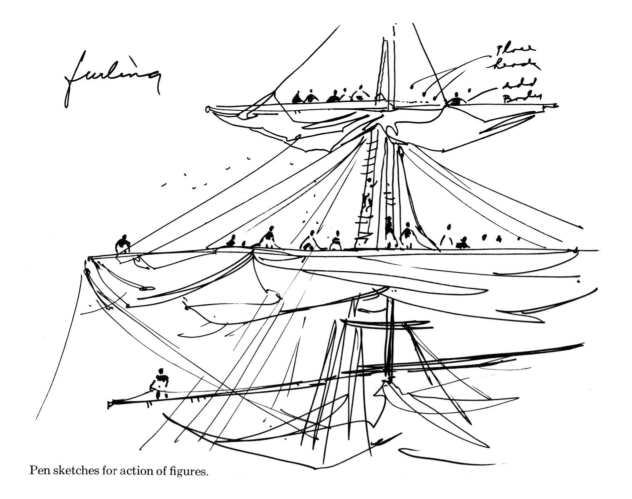

Pen sketches for action of figures.

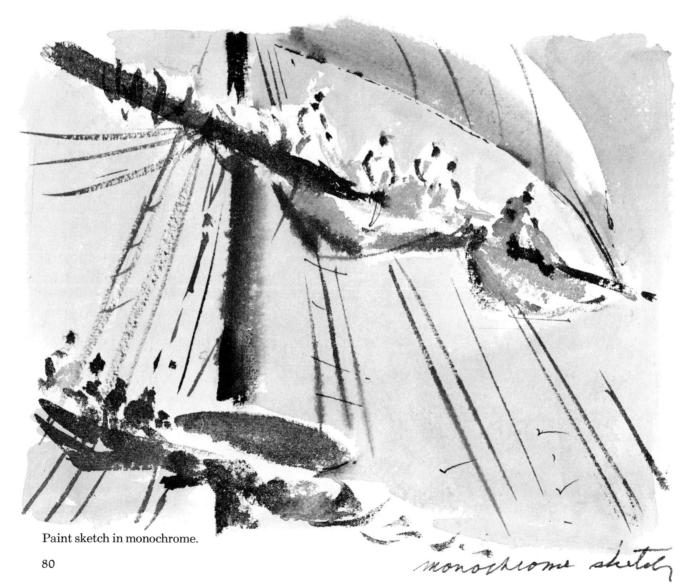

Paint sketch in monochrome.

monochrome sketch

FURLING

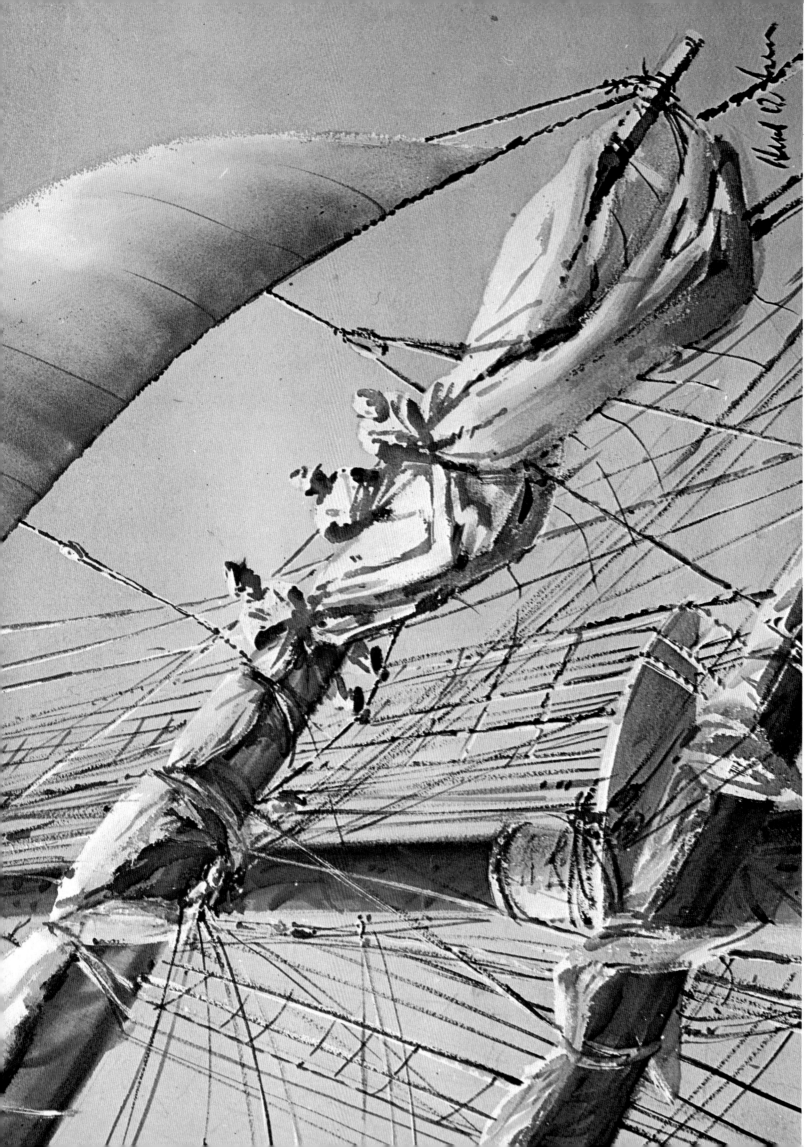

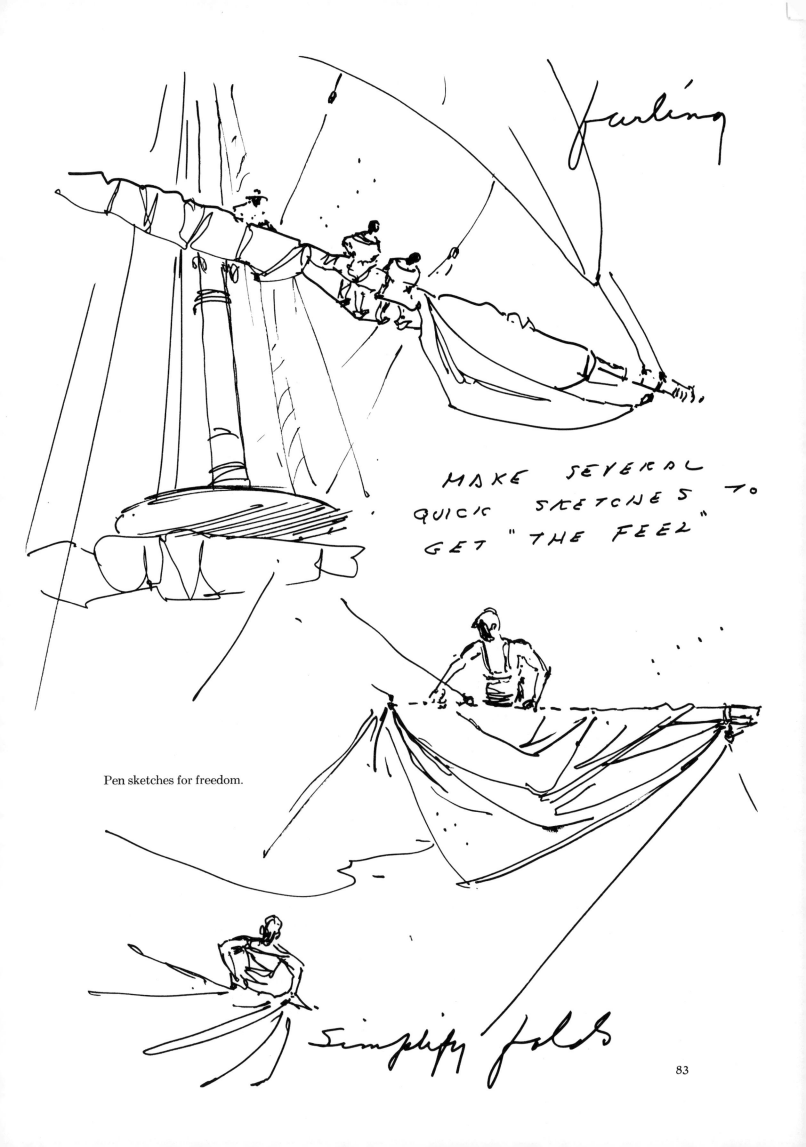

furling

MAKE SEVERAL
QUICK SKETCHES TO
GET "THE FEEL"

Pen sketches for freedom.

Simplify folds

13. TIDES

The periodic rise and fall of the water level of the sea with the resultant changes in the depth of water near the shore, provide a variety of subject matter for the artist. More important of course, it provides a livelihood for many and food for the clam digger and the gourmet.

Watching the changes at the shore is one of the biggest thrills of my life. I'm never quite certain which mood of the ocean is my favorite, but when I see it at low-tide I am sure that is it. The colors of the grasses left exposed by the receded waters, the patterns of the rivulets, and the indefatigable ambition of the clam-diggers in action fascinate me to the point where I have made so many paintings of them in this area that a friend of mine who lives at the water's edge and has the privilege of watching the panorama daily said, "When I look at low-tide I say, 'It looks just like an Olsen painting!'"

Another aspect of the rise and fall of the water level is the effect it has on boats in dock. Any artist who, for the first time, has attempted an on-the-spot painting of a boat anchored in a large body of water, has learned the hard way that "the horizon seems to move." Upon second thought the realization comes that the tide has played tricks on him. One quickly learns that this phenomena must always be taken into account when painting under these circumstances and that each painting session must be limited in duration to avoid disastrous result. How entirely different the same scene can look at high tide and at low tide is dramatically demonstrated on pages 92 and 93.

On the following pages will be seen some rough pencil and ink sketches of the subject matter that show how I go about gathering material for my paintings. Together with photographs, these sketches provide a rich source of picture material. I try to make it a practice never to be without either a sketch-pad or camera and I highly recommend this habit to every artist. A scene can never be recaptured since it is ever-changing, therefore material gathered in this way is invaluable. Two examples of paintings finished from these sources are reproduced in color on page 87.

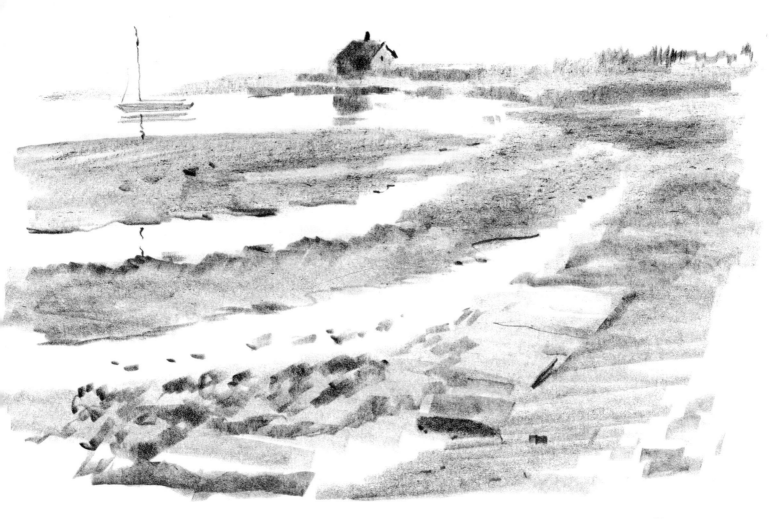

ROUGH PENCIL SKETCHES FOR LOW TIDE

Pencil sketches.

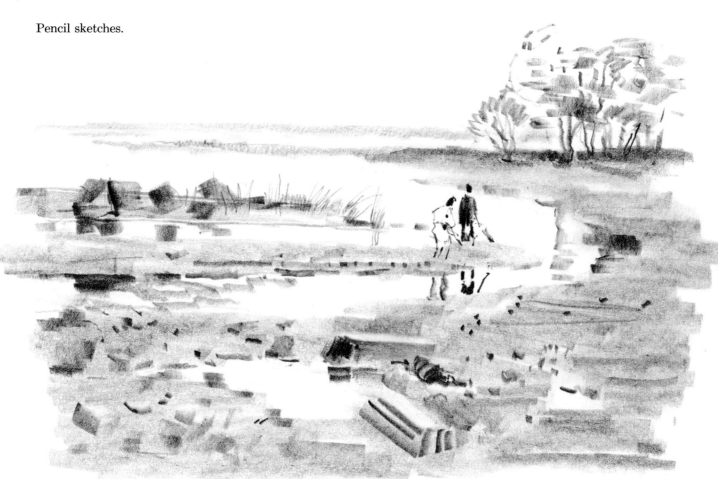

CLAMMERS

LOW TIDE
WESTPORT CONN

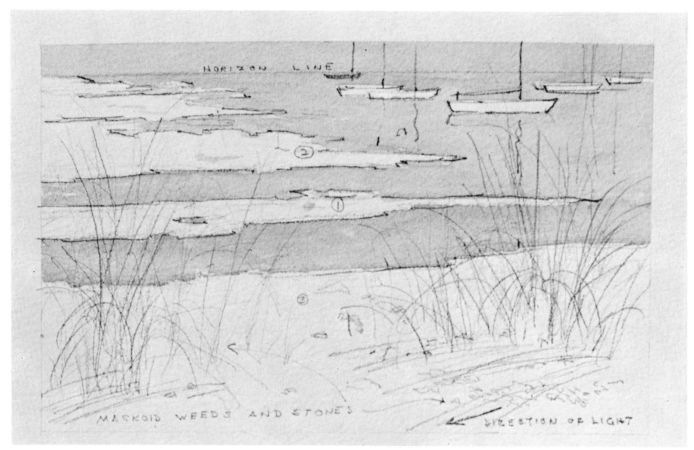

Apply Maskoid to weeds and stones.

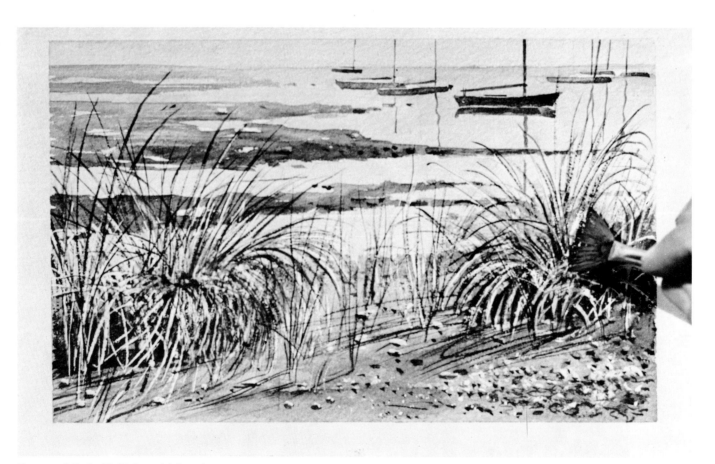

Remove Maskoid. Paint with brush.

86

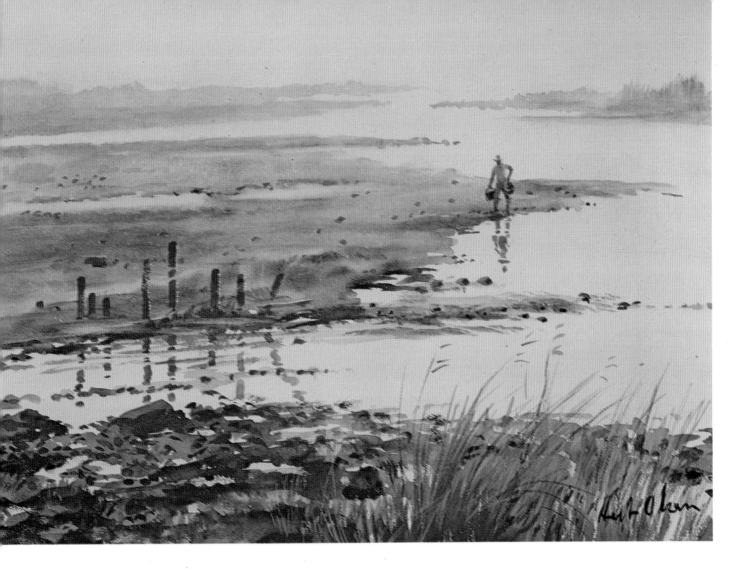

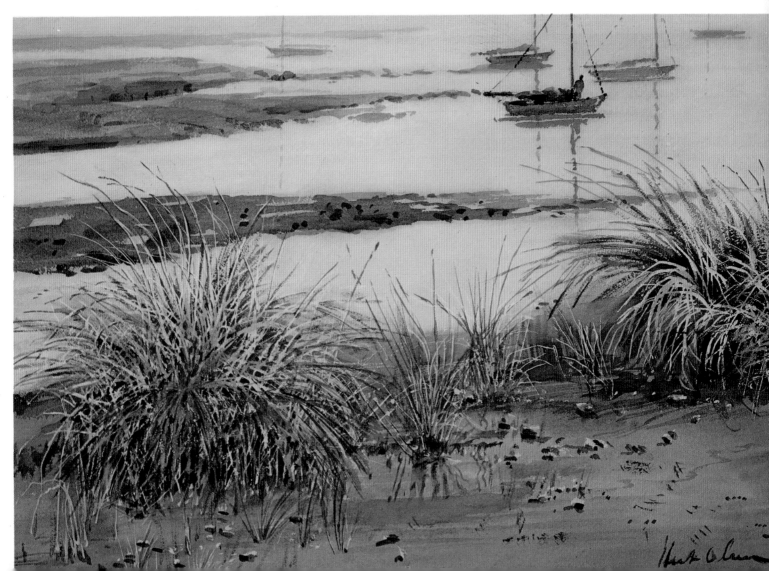

THE CLAM DIGGER

LOW TIDE

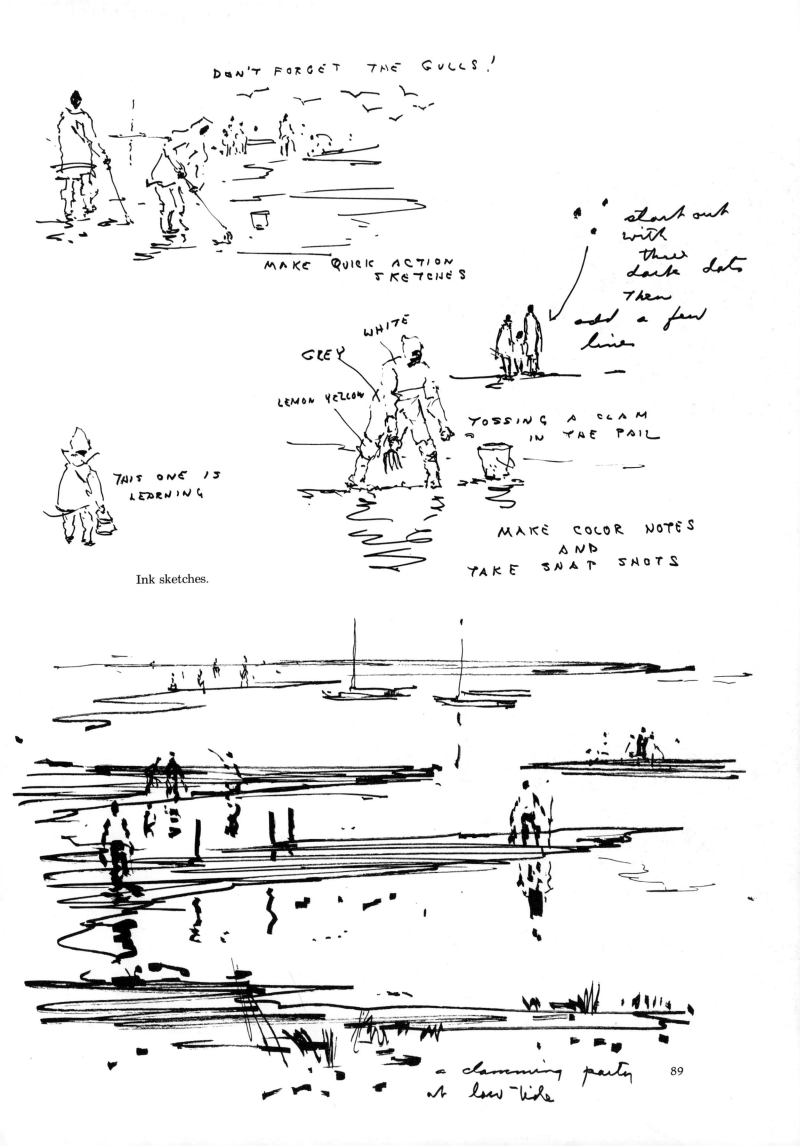

DON'T FORGET THE GULLS!

MAKE QUICK ACTION SKETCHES

start out with three dark dots then add a few lines —

GREY WHITE

LEMON YELLOW

TOSSING A CLAM IN THE PAIL

THIS ONE IS LEARNING

Ink sketches.

MAKE COLOR NOTES AND TAKE SNAP SHOTS

a clamming party at low tide

89

FISHING SHEDS AT LOW TIDE

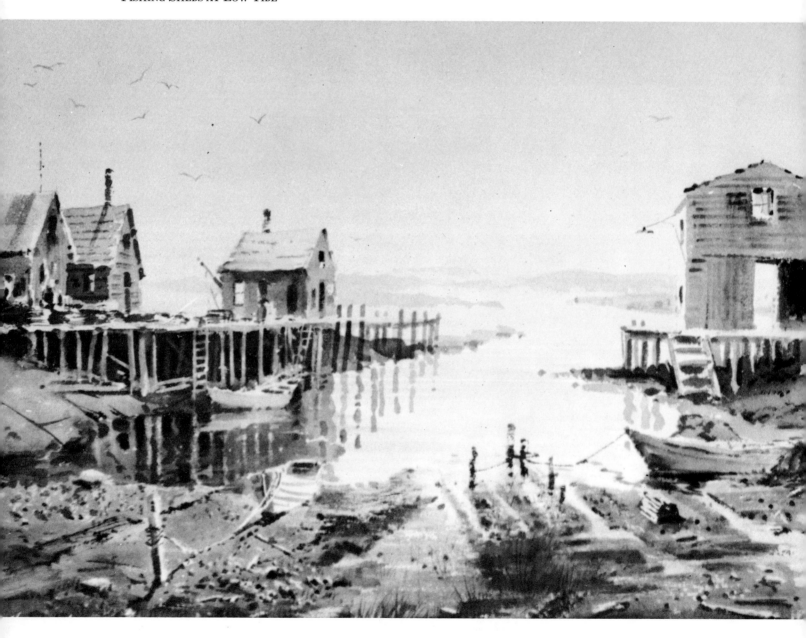

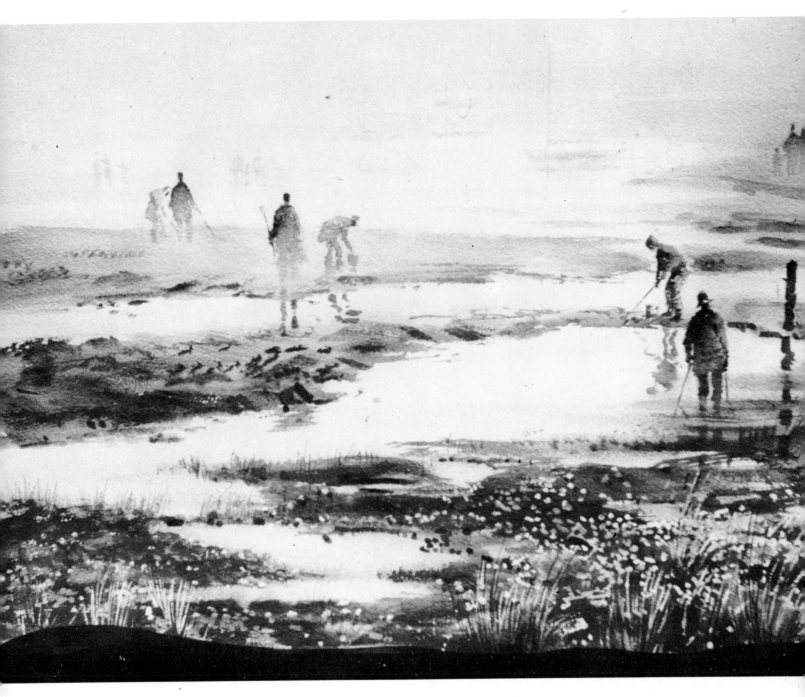

CLAMMING PARTY

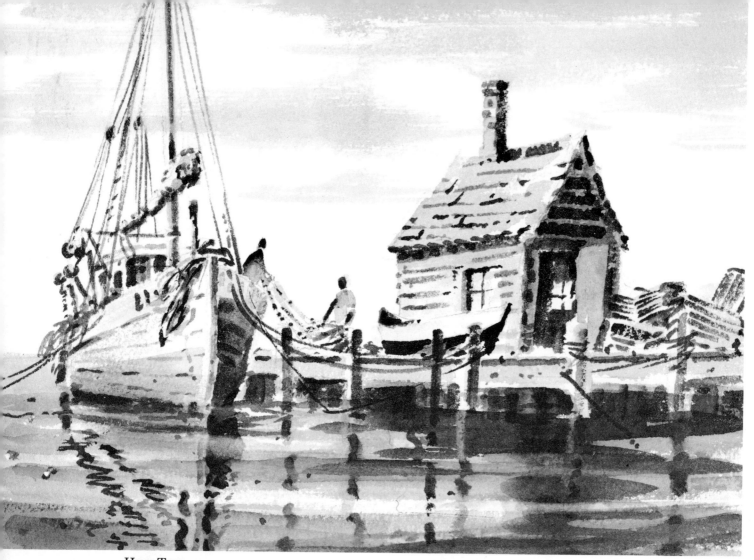

HIGH TIDE

LOW TIDE

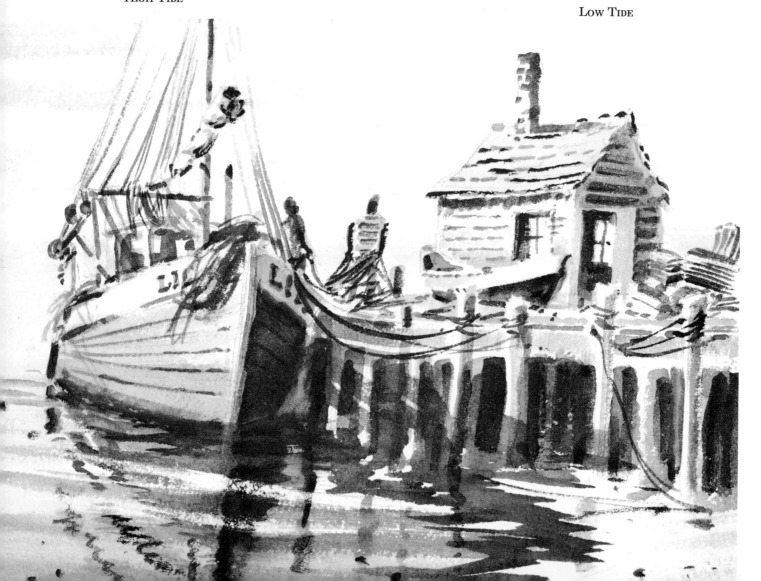

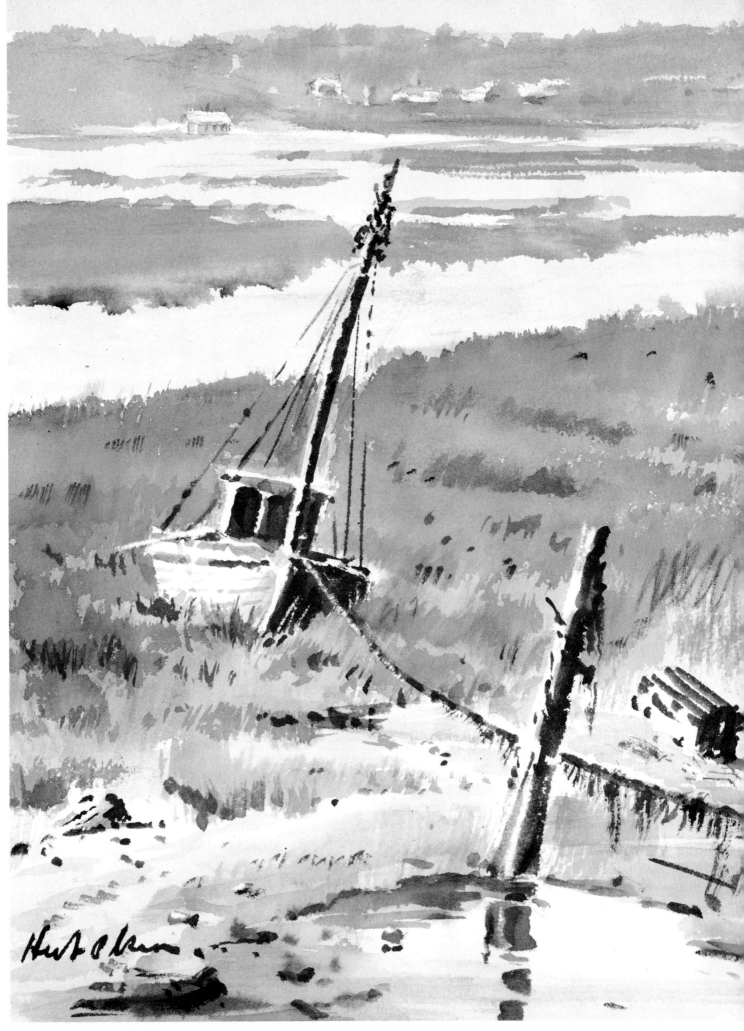

When the tide rises the boat will float—
and the artist will run.

14. THE LIGHTHOUSE

Lighthouses, as everyone knows, are structures for displaying lights at night and operating fog signals in thick weather to warn or guide navigators. They may be divided into two categories: one, those that are built on a reef and surrounded by water, and the other, those that are built on land at the water's edge.

Although in general their shape is cylindrical and most commonly circular, they are often octagonal, hexagonal, or square with only the beacon round, for they are built to conform to the requirements of their location. The increasing knowledge of radio waves and especially the invention of radar are making the earlier forms of lighthouses regretably obsolete but there are still many old landmarks that add much color and atmosphere to the marine scene.

Opposite you will find a very simplified method of laying-in the structure in a drawing, and also the preliminary drawings for the finished painting, LIGHTHOUSE ON ROBBIN'S REEF, reproduced in color on page 97 and on the jacket of this book. Two examples of lighthouses on land and their adjoining buildings are to be seen on page 96. Also see the picture on page 99 showing a lighthouse barely visible through the fog.

The historical background of the lighthouse is perhaps little known to the average artist but it may be of some interest. Therefore, since the lighthouse has played such an important part in navigation and is such a popular subject for paintings, I am including a few pertinent facts about it.

Lighthouses were first built in ancient Egypt, where the priests maintained the beacon fires. The lighthouse of Pharos, built in the third century B.C., was regarded as one of the Seven Wonders of the World. For about 1500 years it guided ships into the Nile; it was lighted by wood fire, showing smoke by day and a glow by night. It was later destroyed by earthquake.

The maintenance of aids to marine navigation in the United States is one of the oldest Federal functions, the work of erecting and maintaining lighthouses being provided for at the first session of Congress in 1789 in the ninth law enacted by Congress. Twelve lighthouses which had previously been built in the Colonies were ceded to the Federal Government and became the nucleus of a system of navigational aids which over a period of 150 years has been increased to a present total of over 29,000.

I would like to add that never do I see one of these dramatic sentinels of the sea without being reminded of the old hymn, "Brightly Beams Our Father's Mercy," in which the author P. P. Bliss uses the allegory of the lighthouse so forcefully:

Brightly beams our Father's mercy
From His lighthouse evermore
But to us He gives the keeping
Of the lights along the shore

Let the lower lights be burning
Send a gleam across the wave
Some poor fainting, struggling seaman
You may rescue, you may save.

DRAWING A LIGHTHOUSE

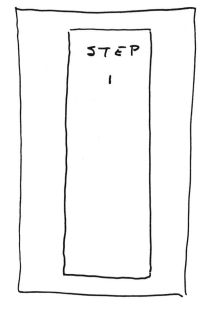

STEP 1

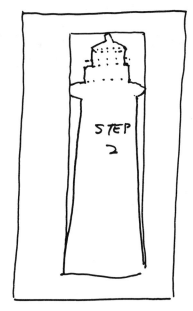

STEP 2

IN DRAWING A LIGHTHOUSE FIRST ESTABLISH THE PROPORTION.
THEN DRAW THE BASIC SHAPE
FINALLY DRAW WITHIN THE SHAPE.
THIS METHOD WILL MAKE YOU SEE THE LARGE SHAPES AND WILL HELP YOU TO ELIMINATE MANY UNNECESSARY DETAILS

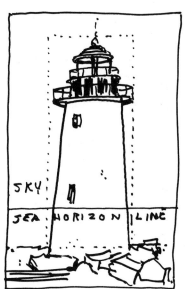

SKY

SEA HORIZON LINE

Laying-in the structure.

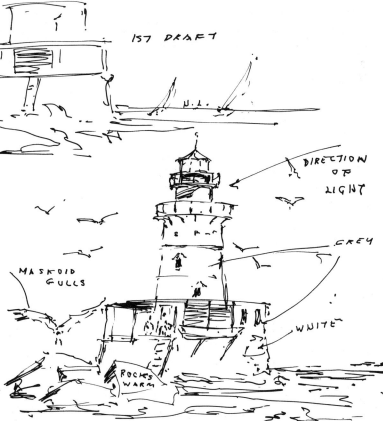

PRELIMINARY DRAWINGS FOR THE LIGHTHOUSE AT ROBBINS REEF

1ST DRAFT

H.L.

DIRECTION OF LIGHT

GREY

WHITE

MASKOID GULLS

ROCKS WARM

COLD BLUES & GREENS FOR SEA

95

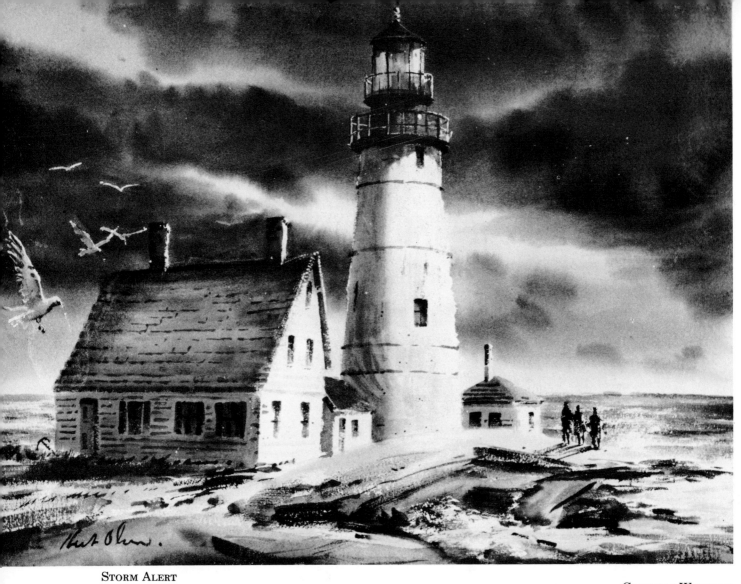

STORM ALERT

CLEARING WEATHER

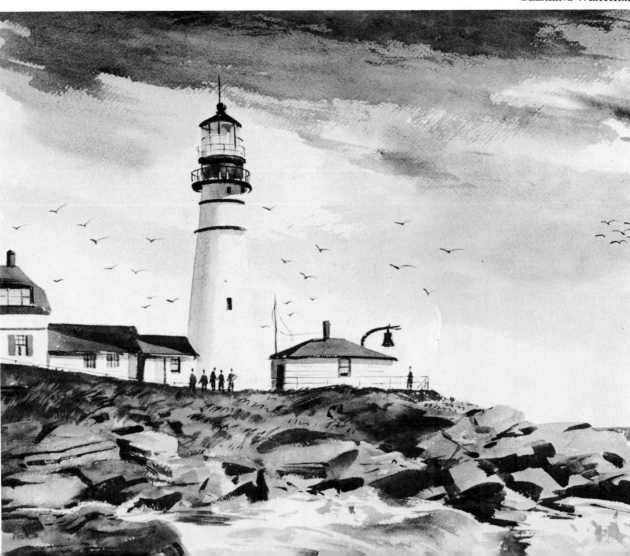

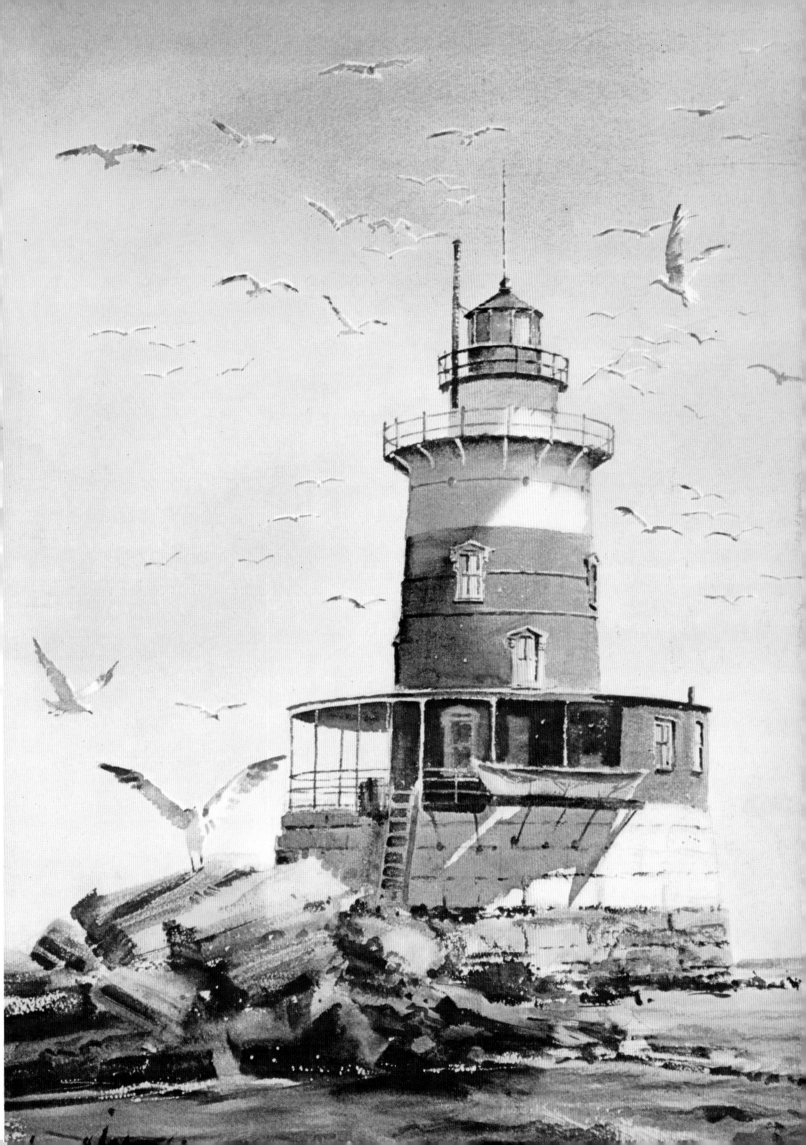

THE LIGHTHOUSE AT ROBBINS REEF

15. FOG

Diabolically, the many hazards of the sea, including hurricanes, typhoons, inclement weather of all kinds, provide the climate for exciting and dramatic pictures.

The most passive of the elements and yet perhaps the most dangerous to the seaman is the stealthy ominous fog, creating an atmosphere of ghost-like quietness and sometimes chilling danger. Fog has been compared to a mass of smoke or dust obscuring the atmosphere and blurring the vision. This analogy, I think, is a good one, and should be kept in mind when painting it. The painting of fog presents an extremely challenging opportunity for a study in depth of subtle values. Unlike rain, it is painted in horizontal strokes since it originates at the surface and rises in layers. One very important thing to remember is that the object closest to the viewer is almost always crisp even though the immediate background is enveloped in fog.

The procedure for painting DRAGGING, reproduced on page 100, and in color on the frontispiece, is as follows: a careful pencil drawing was made, with the exception of the smaller boats in the background which were later painted in the quick-sketch method without preliminary drawing, as described on page 120. Maskoid was then applied to the whites on the large boat and to the crest of the large wave to the left of the boat. (See frontispiece.) When dry, starting at the top of the paper, the sky and sea were painted in with a sponge in horizontal strokes, using Yellow Ochre and Cobalt Blue, mixed on the palette. When dry, the smaller boat in the left background was painted with a Number 8 brush, using the same colors as for the sea. The second boat was painted with the same colors slightly intensified. The sea in the foreground was then painted with an Aquarelle brush and the same colors further intensified and applied in wavy, choppy, strokes. When dry, the Maskoid was removed. The spray effects in the foreground were scraped with a razor blade. The large boat in the foreground was painted lastly using a complete palette with the exception of Mauve, Payne's Grey, and Alizarin Crimson. (See Materials, page 9, for the palette.) Follow the frontispiece as a guide.

Another example of a fog painting, WAITING FOR THE FOG TO LIFT, is also reproduced on page 100, bottom, and on the frontispiece in color. For more examples see pages 101, 102, 103.

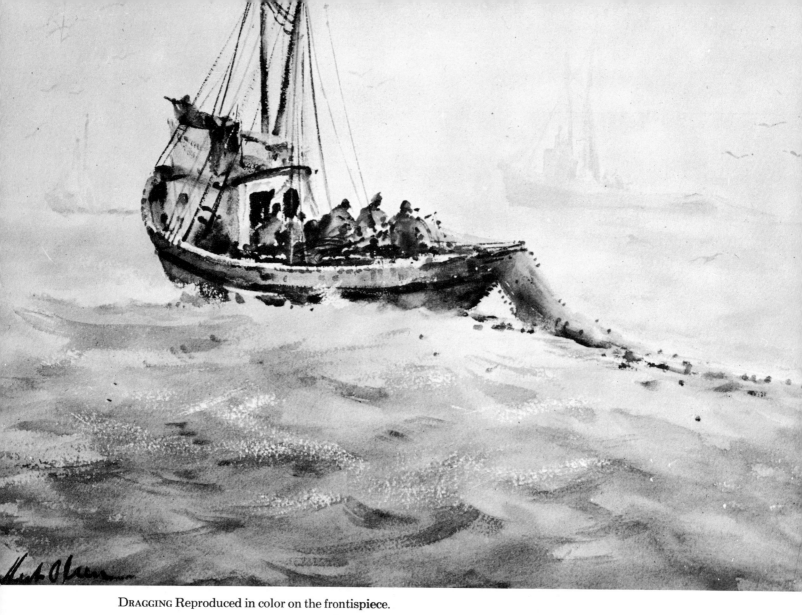

DRAGGING Reproduced in color on the frontispiece.

WAITING FOR THE FOG TO LIFT Reproduced in color on the frontispiece.

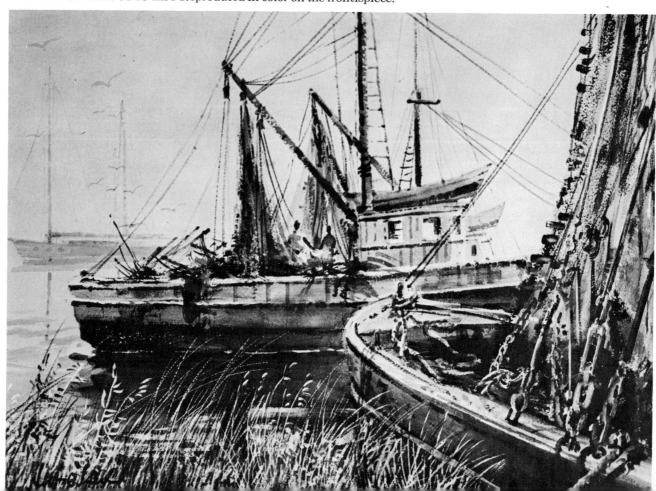

Morning Fog Along the Maine Coast

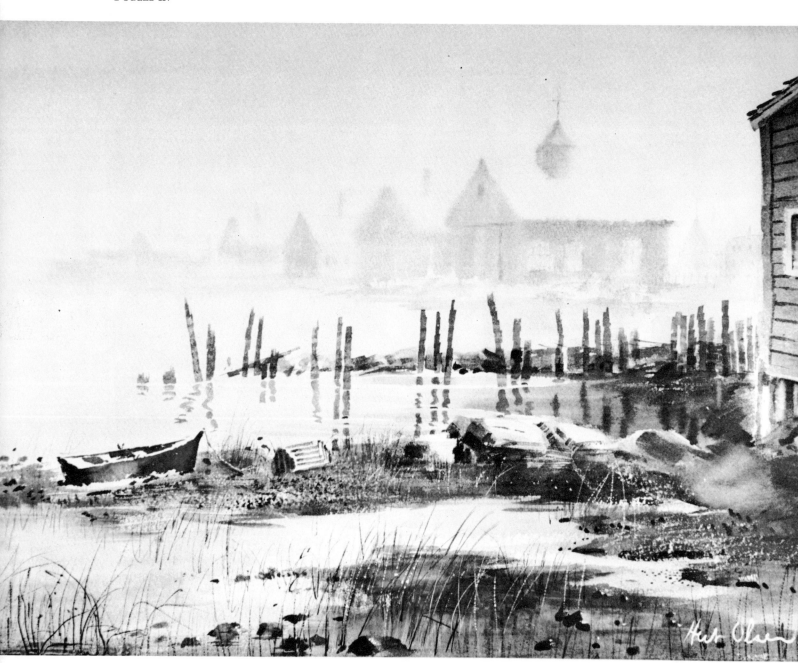

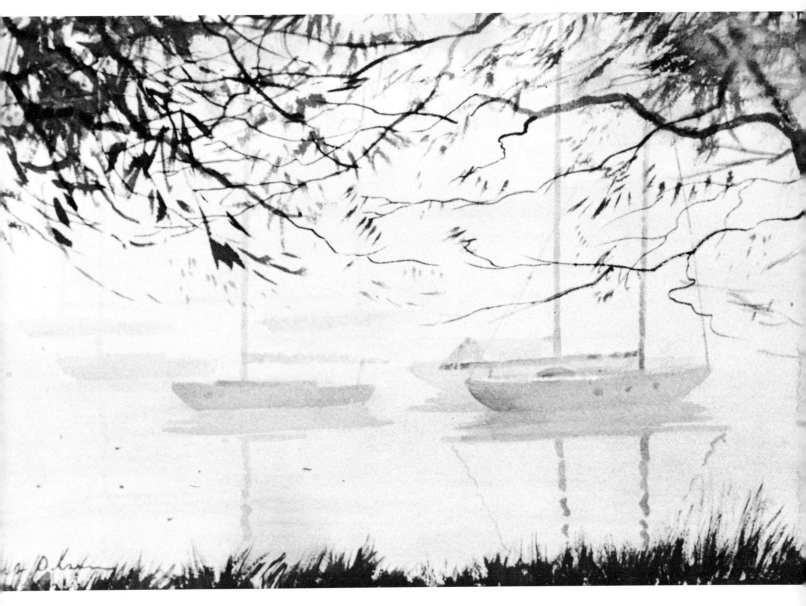

Fog-bound Boats at Anchor

16. THE APPURTENANCES

Accessories associated with the marine scene are many and are familiar to almost everyone. Such adjuncts as shells, buoys, nets, dingies, cork floats, markers, lobster crates, ropes, and pulleys, small though they may be in a painting, still must be drawn carefully in order to come off with any authenticity. On pages 105, 109, 110, 111 are drawings of some of these items to show the details of drawing, but in all cases I suggest the additional help of photographs for more accuracy.

Many times the addition of one or two of the above mentioned appurtenances can change a whole picture. For example, without the shells and driftwood the photograph on page 106, from which SHELLS, DRIFTWOOD, AND OCEAN was painted, could easily be assumed to be just a photograph of landscape anywhere, but because of their addition it takes on the feeling of a marine scene. Even though the shells and driftwood in this case are not in their native locale, they establish the nautical scene by recollection and identification. The finished painting reproduced in color on page 108 does include water which I added for interest and color, but this was not a necessity since the shells and the driftwood in themselves set the stage.

Drawing a shell

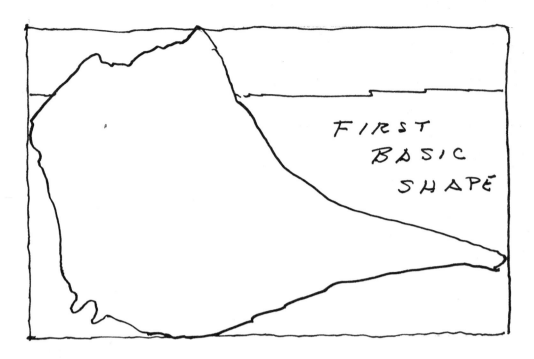

FIRST BASIC SHAPE

The shell shape.

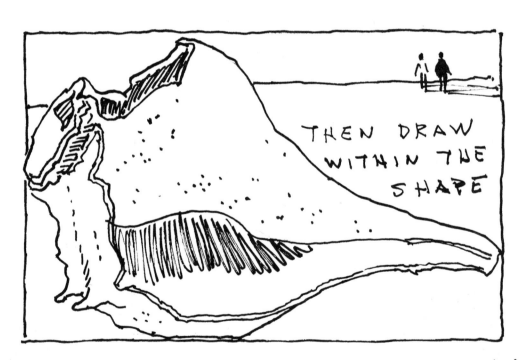

THEN DRAW WITHIN THE SHAPE

TO GET THE RIGHT PROPORTION OF A SHELL DRAW A RECTANGLE THE SIZE AND WIDTH OF THE SHELL. THEN MAKE THE BASIC SHAPE. THIS IS A GOOD RULE TO FOLLOW WHETHER IT BE A SHELL, BOAT OR FIGURE.

105

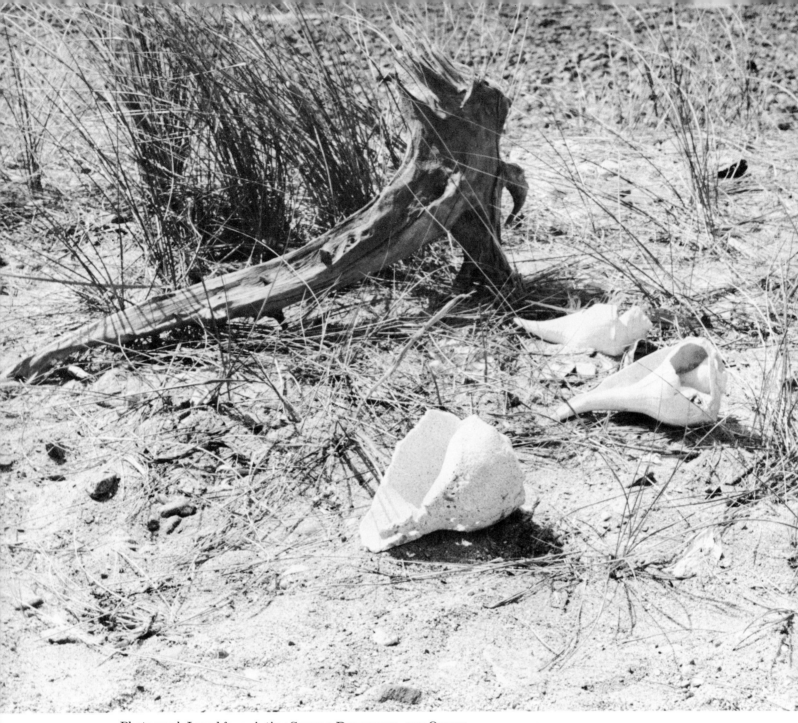

Photograph I used for painting Shells, Driftwood, and Ocean, reproduced in color on page 108.

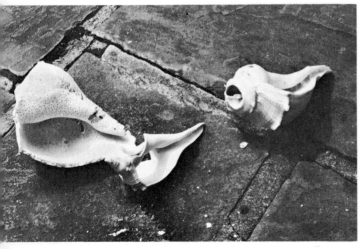

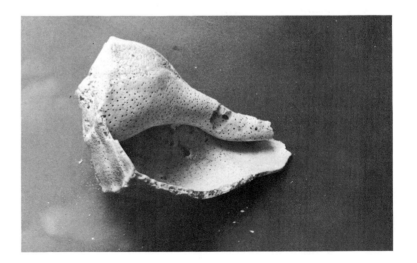

Shell photographs from my reference file.

106

SHELLS, DRIFTWOOD, AND OCEAN

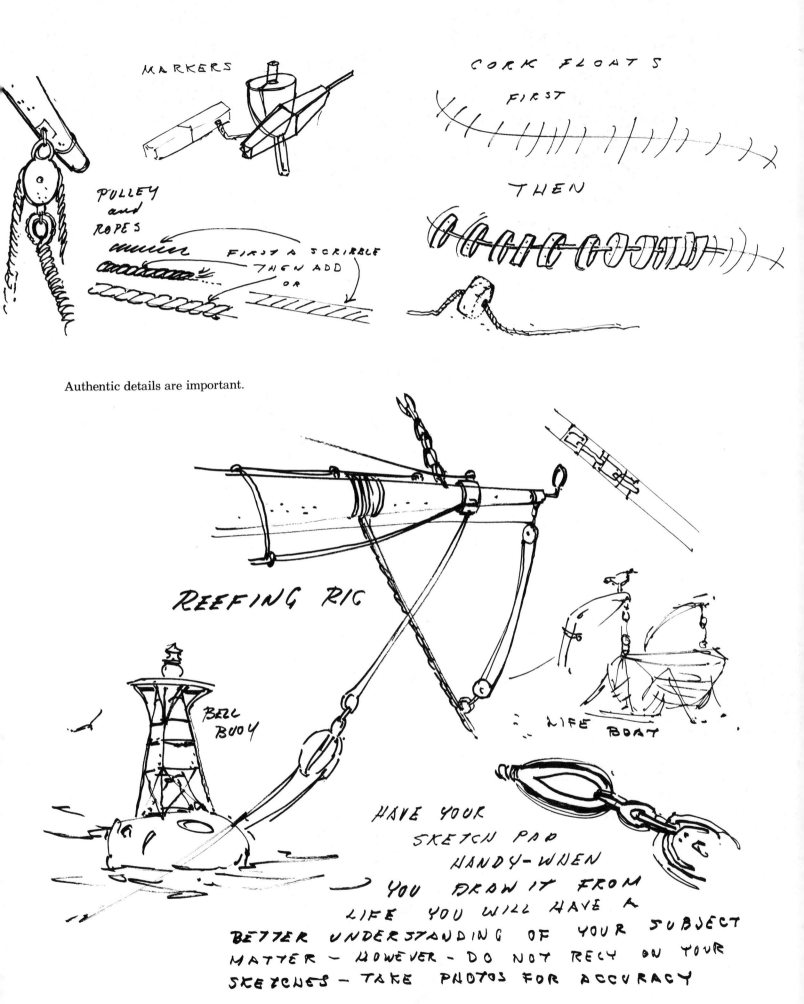

MARKERS

CORK FLOATS

FIRST

THEN

PULLEY and ROPES

FIRST A SCRIBBLE THEN ADD

OR

Authentic details are important.

REEFING RIG

BELL BUOY

LIFE BOAT

HAVE YOUR SKETCH PAD HANDY-WHEN YOU DRAW IT FROM LIFE YOU WILL HAVE A BETTER UNDERSTANDING OF YOUR SUBJECT MATTER - HOWEVER - DO NOT RELY ON YOUR SKETCHES - TAKE PHOTOS FOR ACCURACY

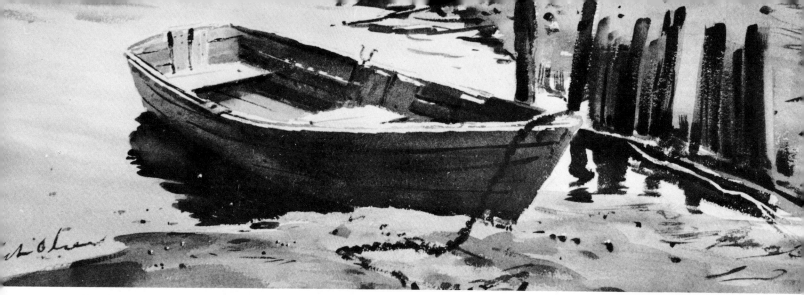

Rowboats are part of the scene.

DRAWING A BOAT

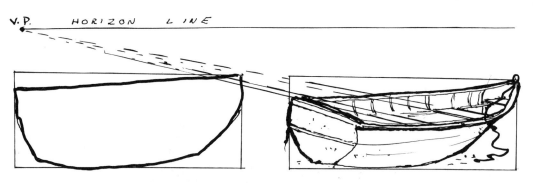

V.P. HORIZON LINE

1- DRAW RECTANGULAR SHAPE

2- PLACE SHAPE OF BOAT IN RECTANGLE

3- ESTABLISH HORIZON LINE

4- DRAW BOAT

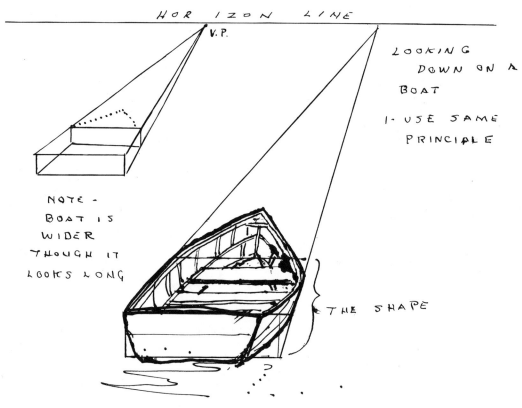

HORIZON LINE

V.P.

LOOKING DOWN ON A BOAT

1- USE SAME PRINCIPLE

NOTE - BOAT IS WIDER THOUGH IT LOOKS LONG

THE SHAPE

ALWAYS ESTABLISH THE SHAPE FIRST

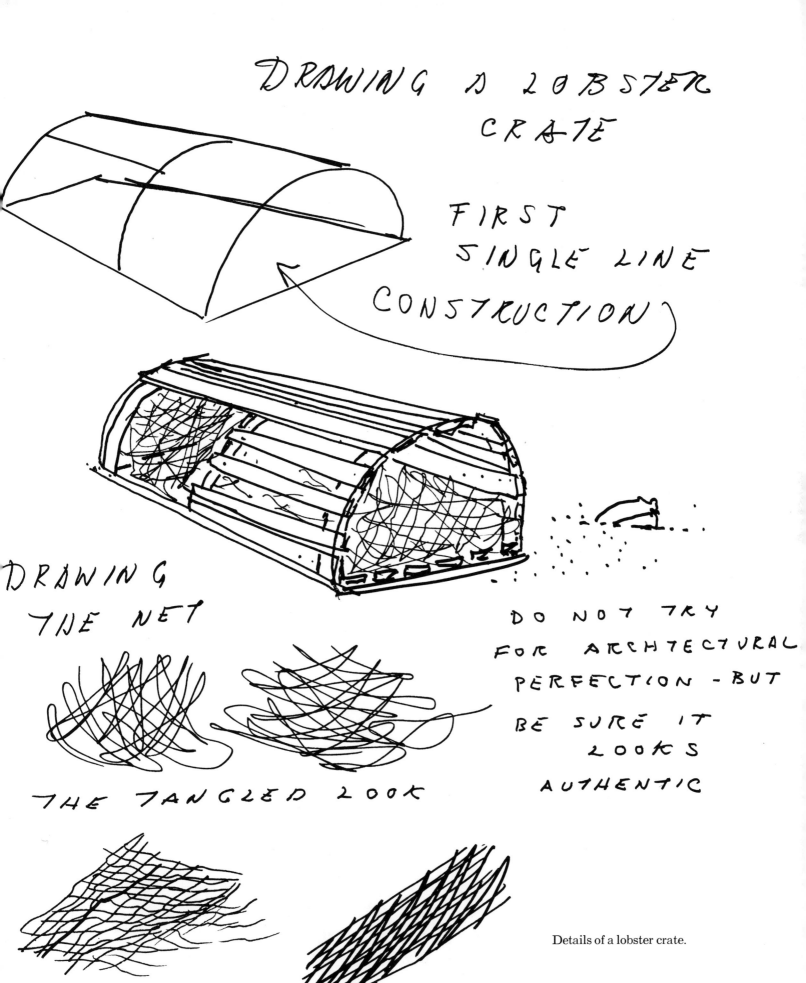

DRAWING A LOBSTER CRATE

FIRST
SINGLE LINE
CONSTRUCTION

DRAWING
THE NET

DO NOT TRY
FOR ARCHTECTURAL
PERFECTION - BUT

BE SURE IT
LOOKS
AUTHENTIC

THE TANGLED LOOK

Details of a lobster crate.

THE UNTANGLED LOOK

USE BOTH

17. GASPE PENINSULA

The very quaint and antiquated setting for HARBOR ROAD, opposite, is the picturesque Gaspé Peninsula, Quebec, Canada. The primitive horse-drawn cart is on its way to the harbor to pick up a load of freshly caught cod and take it into town. This is another example of a painting where the water is not shown in the picture but because the occupation is the result of a day's labor on the sea it can certainly be classified as part of the marine scene. The photograph below shows fishermen cleaning the cod before tossing them into the cart. The two-wheel cart and the cleaning table are typical appurtenances of the fisheries in this region.

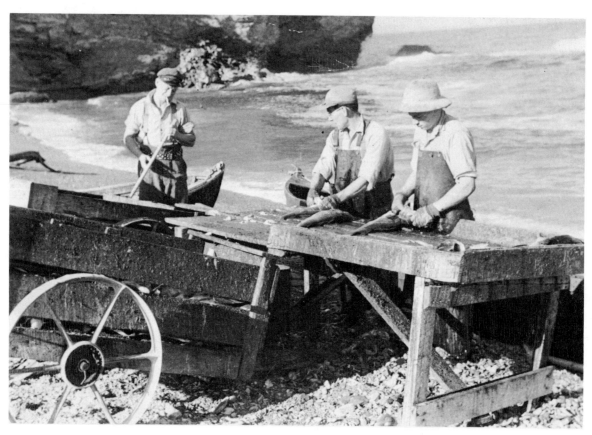

Photograph of Gaspé fishermen cleaning cod.

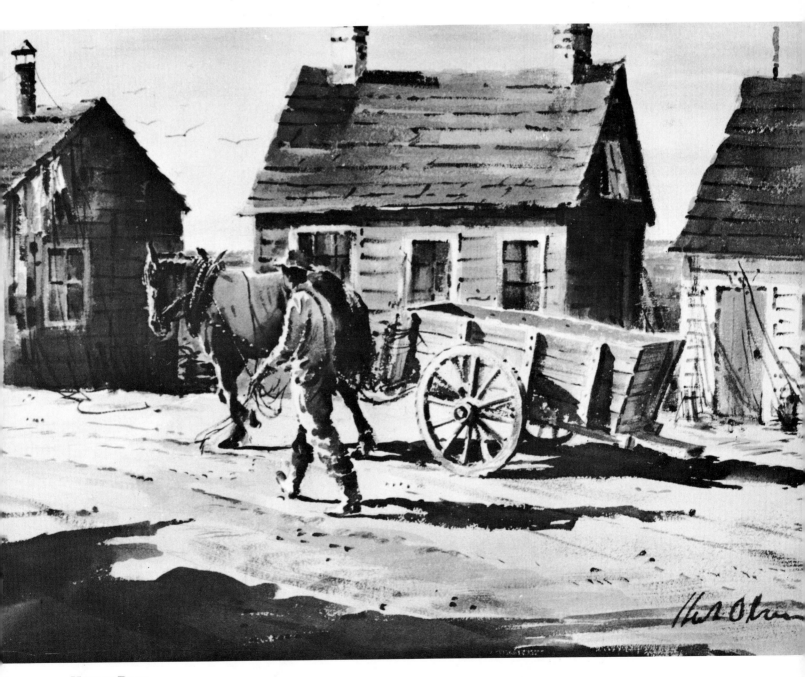

HARBOR ROAD

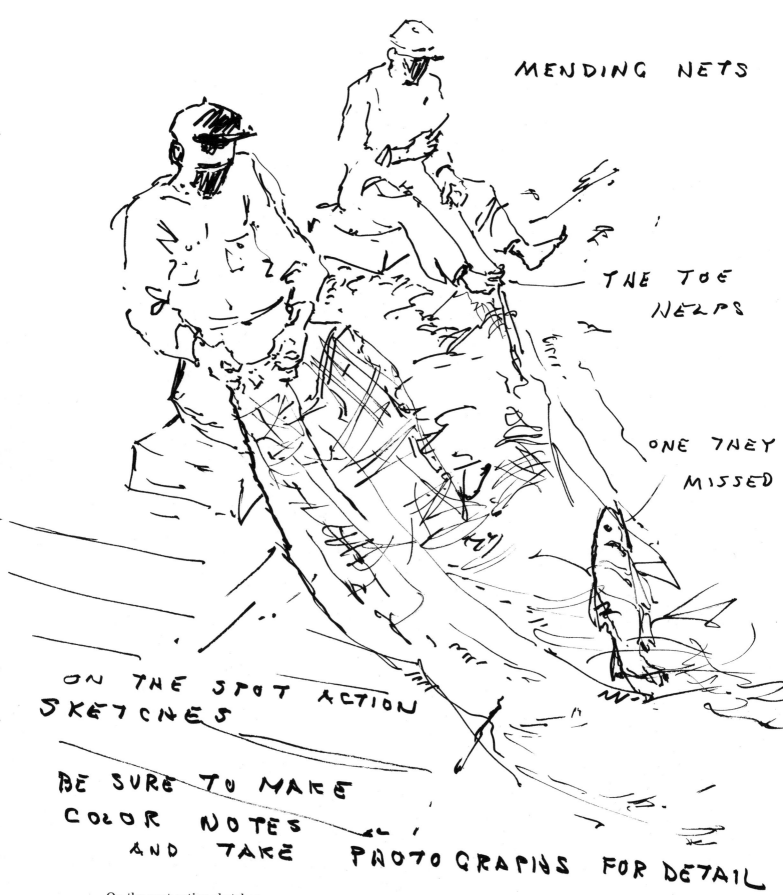

MENDING NETS

THE TOE
NELPS

ONE THEY
MISSED

ON THE SPOT ACTION
SKETCHES

BE SURE TO MAKE
COLOR NOTES
AND TAKE PHOTOGRAPHS FOR DETAIL

On-the-spot action sketches.

18. GULLS

Gulls are indigenous to most water areas and add so much atmosphere, decoration, and grace to a marine painting that it is important to make a study of them in order to be able to paint them with confidence.

The gull is found near all oceans and along many inland waters. The name "sea gull" is commonly applied to the herring gull which is the most familiar species of sea bird in America. Gulls belong to the same family as terns but are larger and have heavier bodies. Webbed feet and a strong horny hooked bill make them excellent fishers. Plumage is usually gray and white with black on the wings and tail. Although they eat fish, clams, and grasshoppers, most gulls feed chiefly on wastes in harbors and bays and are therefore useful scavengers.

I have observed that when gulls fly in groups they generally fly in one direction as if following a leader. For the painting GULLS IN FLIGHT, reproduced in color on page 118, I wanted to incorporate several of them flying in an opposite direction, for the purposes of composition and a more interesting pattern, but was not sure that it would be authentic. After many days of bird-watching, I was rewarded by the unusual appearance of a couple of individualists who were not afraid to fly against the current, so my vigilance paid off and as a result I think my painting was improved.

On the following pages are shown sketches and photographs of gulls in a great variety of positions—diving, soaring, flying, alighting, and even just walking around on the shore. Practice sketches of this kind will prove invaluable when you start planning a marine painting.

INK DRAWINGS OF
GULLS IN ACTION

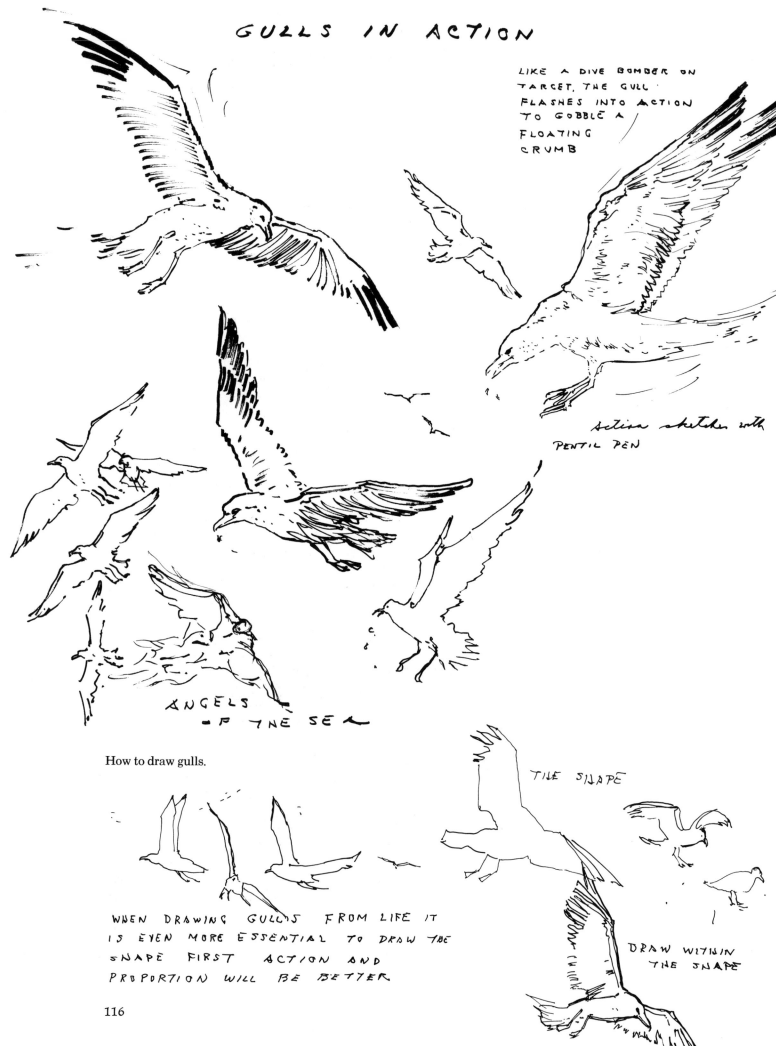

LIKE A DIVE BOMBER ON
TARGET, THE GULL
FLASHES INTO ACTION
TO GOBBLE A
FLOATING
CRUMB

action sketches with
PENTIL PEN

ANGELS
OF THE SEA

How to draw gulls.

THE SHAPE

DRAW WITHIN
THE SHAPE

WHEN DRAWING GULLS FROM LIFE IT
IS EVEN MORE ESSENTIAL TO DRAW THE
SHAPE FIRST ACTION AND
PROPORTION WILL BE BETTER

SALMON FISHERMEN

GULLS IN FLIGHT

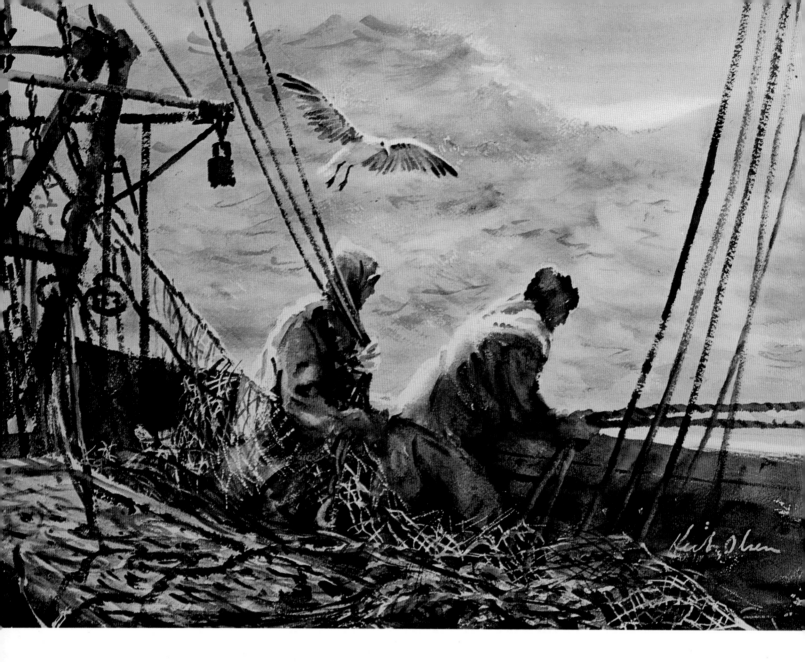

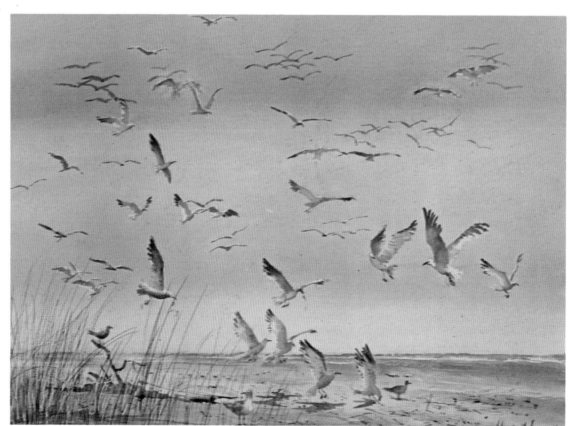

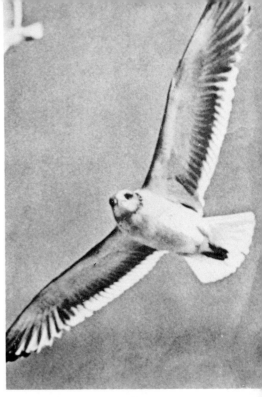
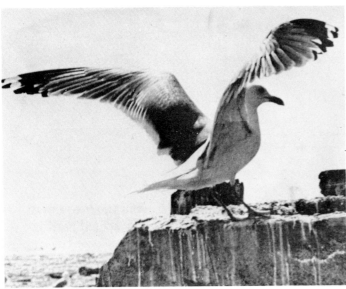

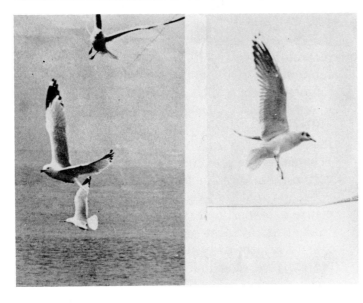
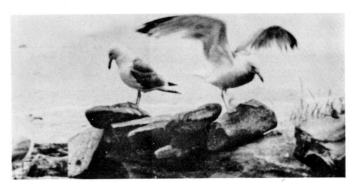

Photographing gulls is useful fun.

19. THE QUICK SKETCH

The quick paint sketch is the antidote for the artist who has a tendency to be too tight in his renditions and is bothered by his inability to loosen up. "How can I get a freer or looser quality in my painting?" is a very frequently asked question. It is not the easiest one to answer because some artists do not have it in their temperaments. They strive so desperately for perfection and accuracy that the result is a tight painting.

Artistically there is nothing wrong with this style of work and it may even be preferred by some. This is a matter of personal taste. But for those who are striving for a freer style, the quick paint sketch, without any drawing, is a highly recommended exercise.

The actual physical handling of the brush is of utmost importance. The tendency of the "rigid" painter is to hold his brush in an almost vise-like grip. As I have mentioned before, the brush should always be held so loosely that it could be slapped out of the hand with a slight tap on the wrist. Also a loose arm movement from the shoulder allows the application of color to be more free. A third and important thing to keep in mind is to avoid the over-use of too small brushes, the result of which is to increase the tight effect.

When first attempting these quick sketches it is advisable to use only one color before trying to do them in full color. Shown on pages 121, 122, 123, and 124 are four examples of quick one-color sketches done without any pencil drawing whatsoever. There is a two-minute, a ten-minute, a fifteen-minute, and a twenty-minute sketch. A full color sketch done in thirty minutes is shown on page 125.

The time element is not of any particular importance—the sketches were timed merely to demonstrate approximately what can be done within these time limits. The important thing is to show that the looseness of the sketch is of course in proportion to the time spent on it and to demonstrate just how far each one can be taken when the execution is free, with little attention paid to detail. Facility in doing such quick sketches takes practice, but in my opinion it is time well spent and does pay off in an ultimately freer feeling that can be incorporated into a personal painting style.

Two-minute sketch.

2 MINUTE · SKETCH
QUICK IMPRESSION

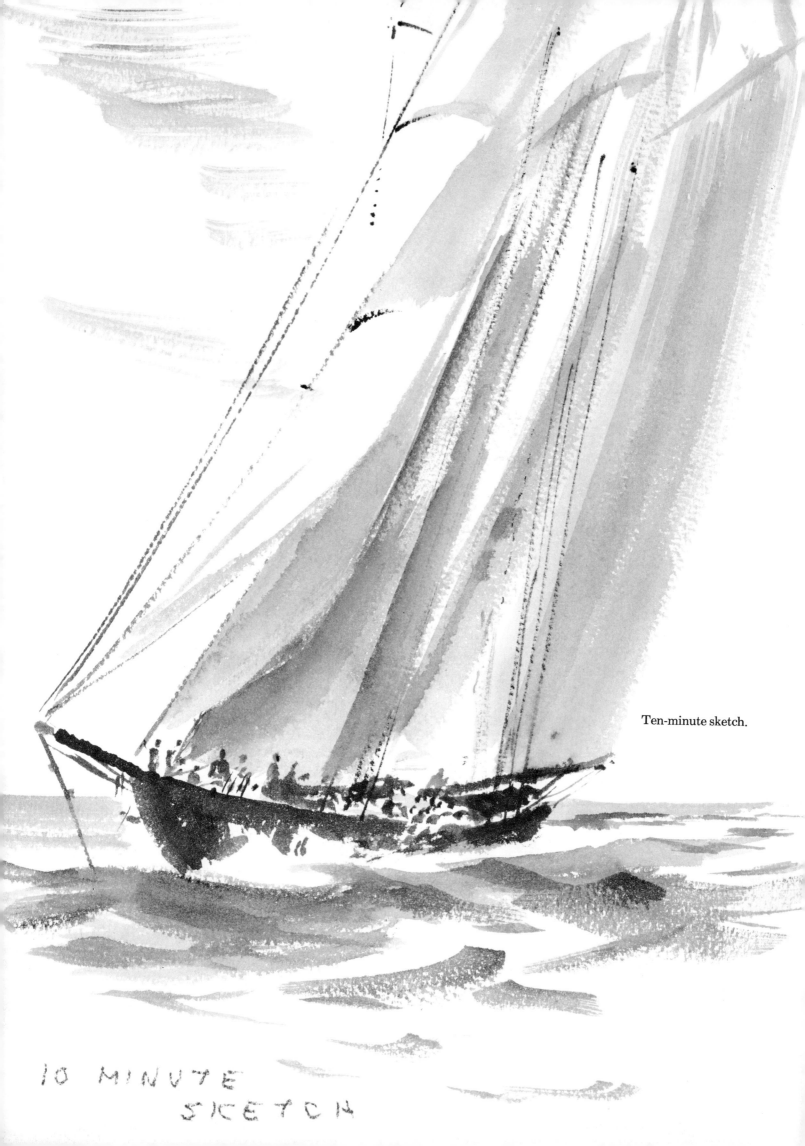

Ten-minute sketch.

10 MINUTE
SKETCH

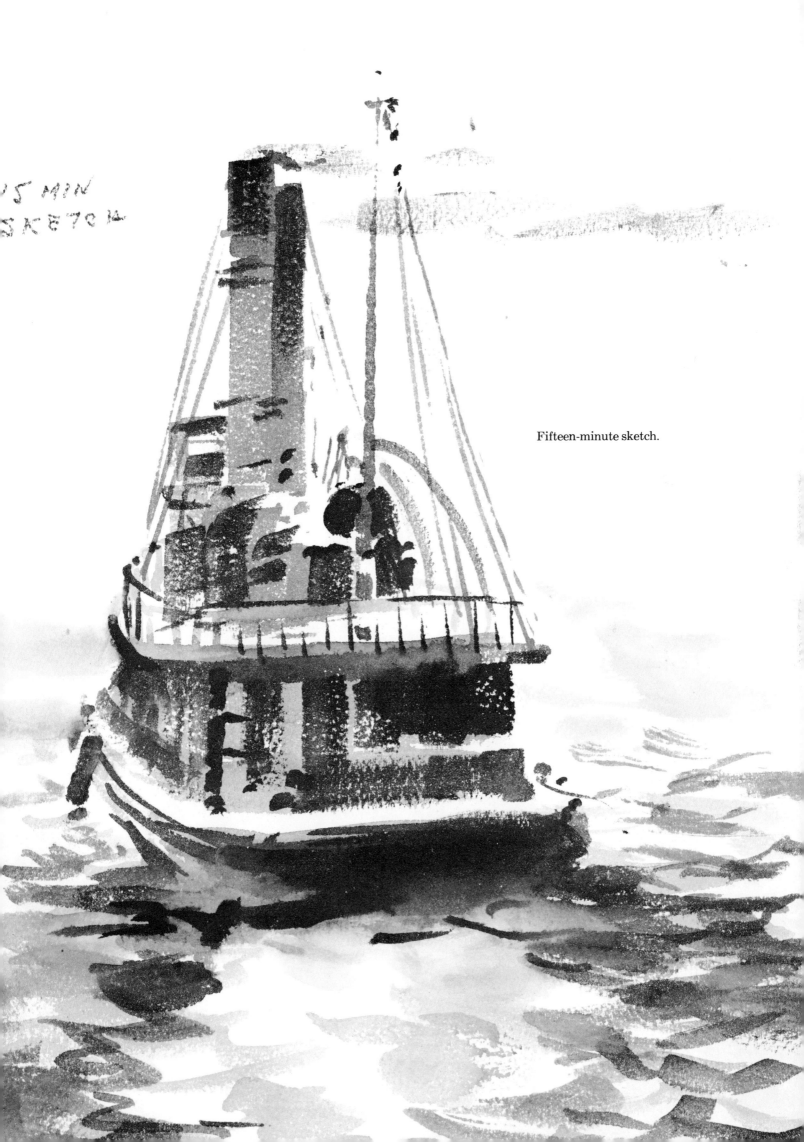

Fifteen-minute sketch.

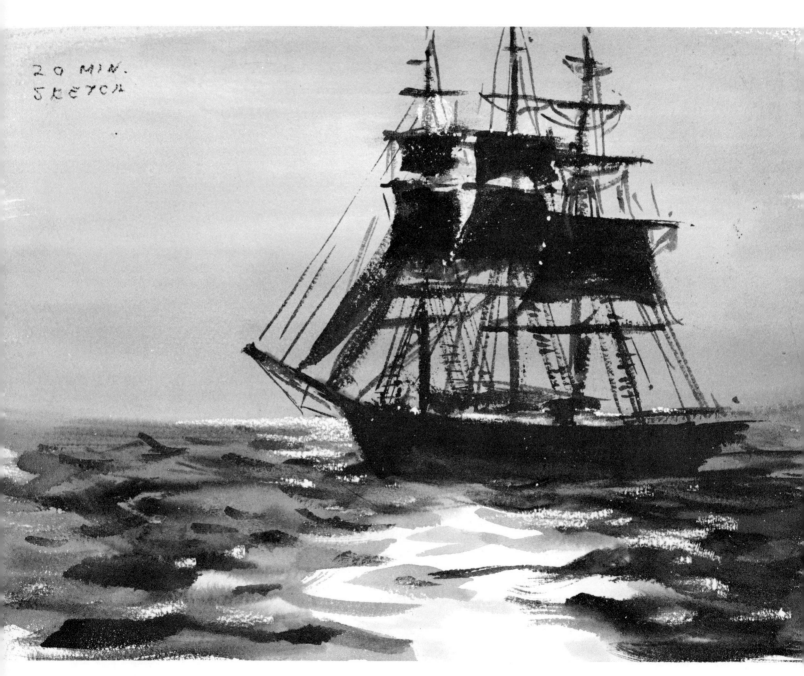

Twenty-minute sketch.

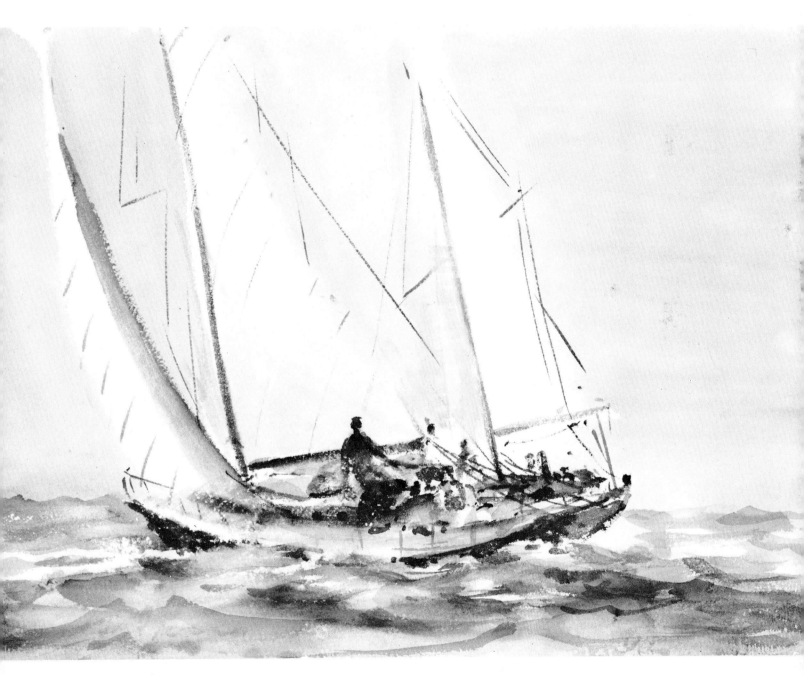

Full color sketch painted in thirty minutes.

20. SOLITUDE

I saunter by the shore and lose myself
In the blue waters, stretching on, and on . . .
To be alone—but I am not alone,
For solitude like this is populous.

I have been walking on the yellow sands,
Watching the long, white, ragged fringe of foam
The waves had washed up on the curves of beach
The endless fluctuating of the waves.

from "A Hymn To The Sea" by
Richard Henry Stoddard

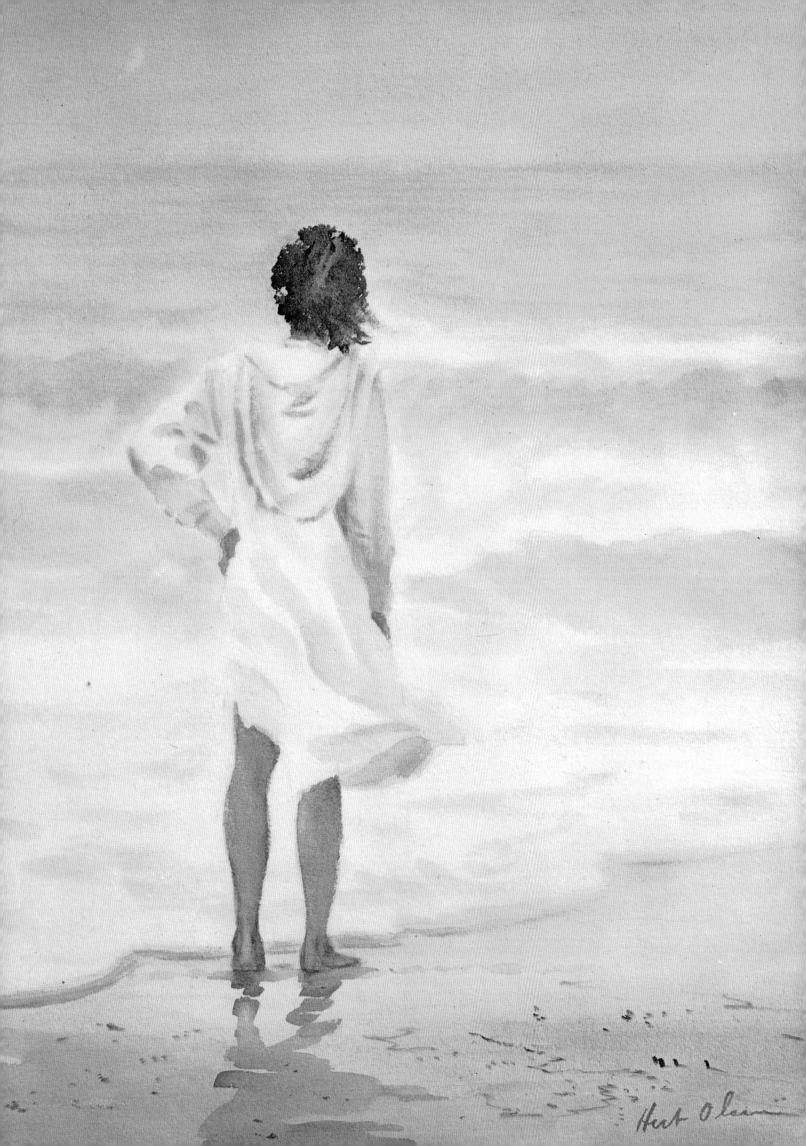

Acknowledgments

My thanks are expressed to publishers and authors for permission to quote the lines of poetry that appear in this book; *from* "Sea" by Don Gordon, page 7, Bruce Humphries, Publishers, Boston, Massachusetts; *from* "A Wet Sheet and a Flowing Sea" by Allan Cunningham, page 47; *from* "The Fisherman" by Abbie Farwell Brown, page 54, Houghton Mifflin Company, Boston, Massachusetts; *from* "Pictures" by C. Fox Smith, page 62, Metheun & Co., Ltd., London, England; *from* "A Hymn to the Sea" by Richard Henry Stoddard, page 126, Charles Scribner's Sons, New York, New York.